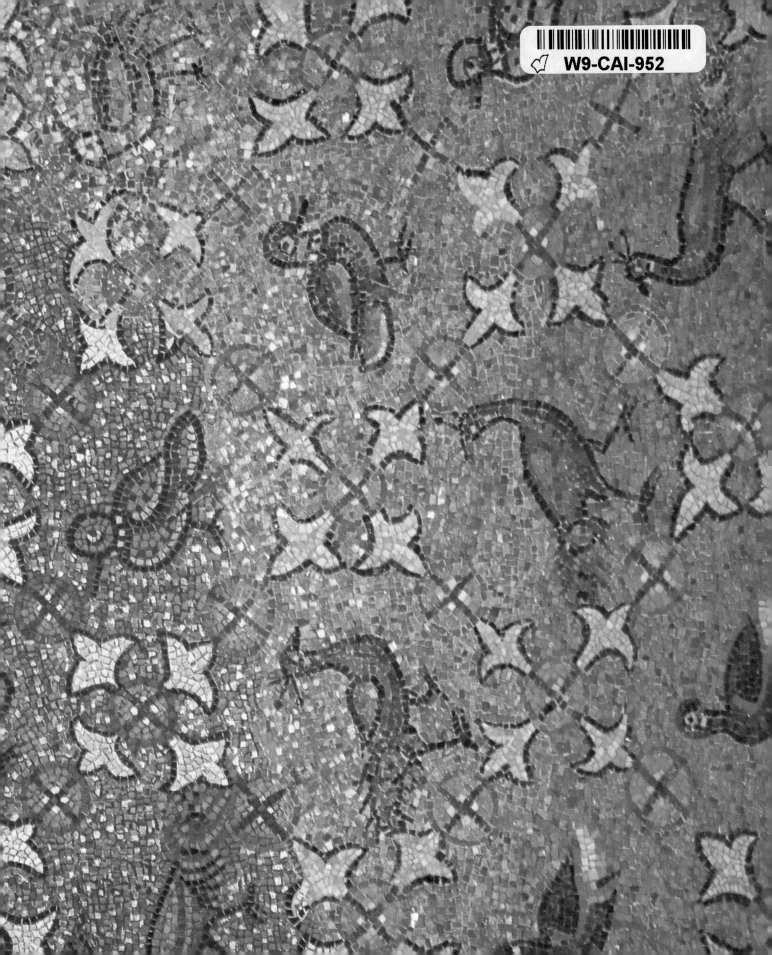

MAKING MOSAICS

Designs, Techniques & Projects

Elaine M. Goodwin, *Foreplay II*, white and yellow gold, marble, and smalti, 13½" x 12¼" (34 x 31 cm), 1993

MAKING MOSAICS

Designs, Techniques & Projects

Leslie Dierks

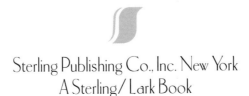

Sterling Publishing Co., Inc. New York
A Sterling/Lark Book

Art Director: Celia Naranjo
Illustrations: Kay Holmes Stafford
Production: Celia Naranjo

Library of Congress Cataloging-in-Publication Data
Dierks, Leslie.
 Making mosaics : designs, techniques & projects / Leslie Dierks.
 p. cm.
 "A Sterling/Lark book."
 Includes index.
 ISBN 0-8069-4872-8
 1. Mosaics—Technique. I. Title.
 TT910.D53 1997
 738.5 —dc20 96-31470
 CIP

10 9 8 7 6 5 4

A Sterling/Lark Book

Published by Sterling Publishing Company, Inc.
387 Park Avenue South, New York, NY 10016

Created and produced by Altamont Press, Inc.
50 College Street, Asheville, NC 28801

© 1997, Altamont Press

Distributed in Canada by Sterling Publishing,
 c/o Canadian Manda Group, One Atlantic Avenue, Suite 105, Toronto, Ontario, Canada M6K 3E7
Distributed in Great Britain and Europe by Cassell PLC,
 Wellington House, 125 Strand, London, England WC2R 0BB
Distributed in Australia by Capricorn Link (Australia) Pty Ltd.,
 P.O. Box 6651, Baulkham Hills, Business Centre, NSW, Australia 2153

Unless otherwise indicated, the photography is done by the artist whose work is depicted. In-process photography is by Evan Bracken. Photos of mosaics by Karen Barnett are used with permission of *Michaels Arts & Crafts* magazine. For subscriptions or back issues, write to the magazine at 1227 W. Magnolia Ave., Garden Level Suite, Attn: Circulation, Fort Worth, TX 76104 or call 1-800-856-8060.

Printed in Hong Kong

ISBN 0-8069-4872-8

Endpapers: Vault of the Archbishop's Chapel, Ravenna, 6th century; photo by C.M. Dixon
Contents page, clockwise starting at top: Susan Grossman, detail from baptismal font before installation and grouting, St. Mark Roman Catholic Church in Wilmington, North Carolina, marble, 1996; Dee Hardwicke, detail of *Madonna*, handmade ceramic tile with 18K gold glaze, 32" x 41½" (81.5 x 105.5 cm), 1994; Robert Stout, section of *The Pathway*, I, Albuquerque Museum, ceramic tile, entire work is 35' x 30' (10.7 x 9.1 m), 1992; photo by Alan Labb

CONTENTS

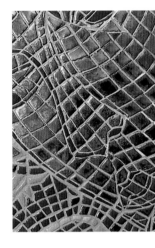
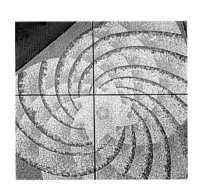

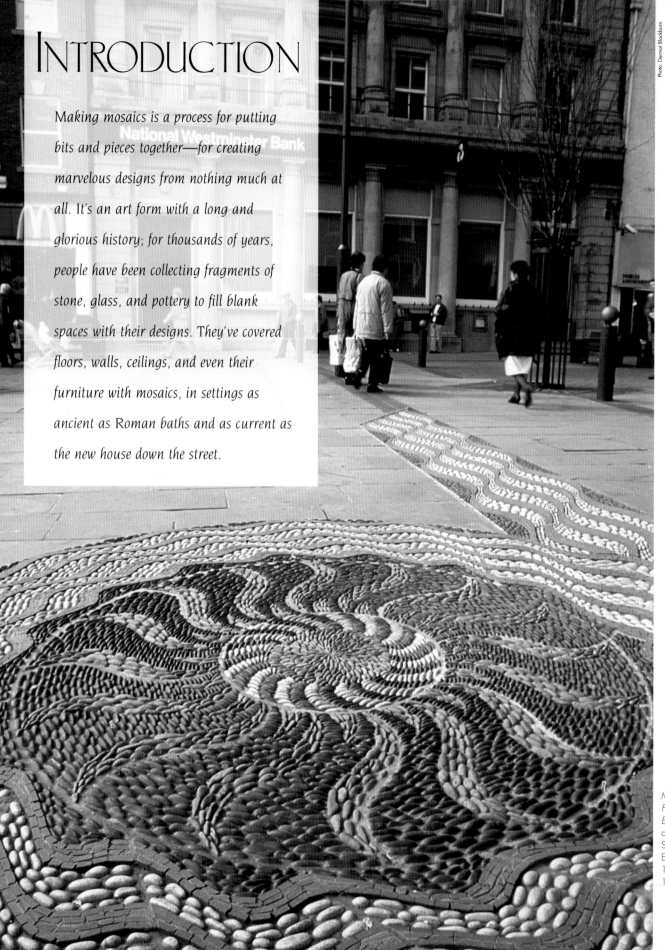

INTRODUCTION

Making mosaics is a process for putting bits and pieces together—for creating marvelous designs from nothing much at all. It's an art form with a long and glorious history; for thousands of years, people have been collecting fragments of stone, glass, and pottery to fill blank spaces with their designs. They've covered floors, walls, ceilings, and even their furniture with mosaics, in settings as ancient as Roman baths and as current as the new house down the street.

Maggy Howarth, *Fire, Water, and Energy*, walkway on High Street in Stockton-on-Tees, England, pebbles, 13' (4 m) diameter, 1994

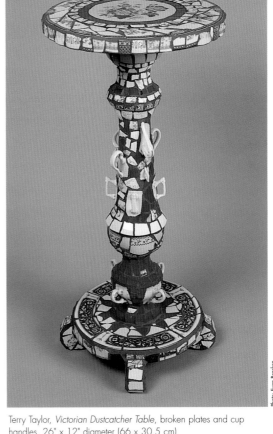

Many of the classic Greek and Roman mosaics were located in public buildings and common areas; and in cathedrals throughout Europe, the Byzantines created brilliant images that continue to instill a sense of wonder among those who attend services there. Public enjoyment inspires contemporary mosaicists as well; modern works grace walkways, libraries, churches, universities, airports, and nearly every other type of structure. Some artists are so captivated with the medium—and so eager to share its delight with others—that they have covered their entire homes with mosaics.

On a more intimate scale, mosaics are equally pleasurable. A colorful stepping stone here and there in the garden adds to the enjoyment of tending to your flowers. In a living room, a brightly patterned table can provide just the right touch to a dull corner. Wall plaques and free-standing sculptures are wonderful enhancements to any setting.

Despite the apparent complexity of the finished designs, the tools and techniques for making mosaics are simple. With just a little experience, you'll find they're easily mastered. The process appeals equally well to adults and young people, making it an ideal family activity. Its relatively leisurely pace and steady progress are immensely satisfying, and some of the most dramatic results are achieved with the least complicated of materials.

Terry Taylor, *Victorian Dustcatcher Table*, broken plates and cup handles, 26" x 12" diameter (66 x 30.5 cm)

From simple geometric patterns to intricate motifs, the design possibilities for mosaics are endless. Styles range from classic to contemporary, and you can vary the palette from a rainbow of colors to just one or two.

In the pages that follow, you'll find everything you need to learn to create your own mosaics. Helpful advice from professionals will guide your first steps, and works by more than 50 contemporary artists will inspire your creativity. To get you underway, a dozen mosaic projects are described in step-by-step detail.

There's just one caveat for what you're about to undertake. Once you start making mosaics, you'll find your entire outlook has changed. Where once you thought a shard of glass or a broken cup was worthy only of the trash can, now you will look mainly at its potential use as material for your next design.

Michael Mah, Duncan Gamble, and Ben Doyle work on a wall mural for the Science and Arts Building at Berkeley (California) High School. Under the guidance of Chere Lai Mah, more than 30 students participated in the design and execution of the 4'8" x 11' (1.4 x 1.3 m) mosaic/painted tile mural.

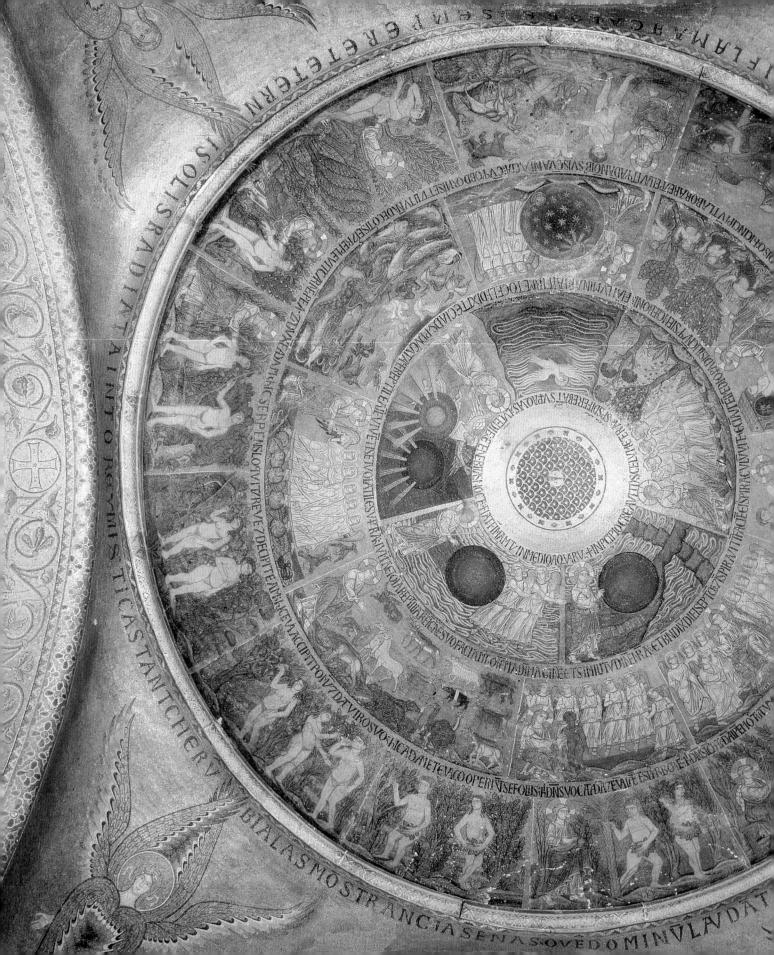

A HISTORY OF MOSAICS

Mosaic is a contemporary art form with ancient roots and a rich cultural heritage. Mosaics were first created thousands of years ago and have appeared in cultures around the world and at different times in history ever since. Although some magnificent finds indicate that peoples as widely dispersed in time and place as the Aztecs in Central America and the natives of New Guinea created mosaics as sacred objects, the preponderance of lasting examples shows that contemporary methods and styles derive mainly from European and Near Eastern traditions.

Mosaic of the Creation, Cupola in the Vestibule of San Marco Basilica, Venice, San Marco, Venice/Bridgeman Art Library, London

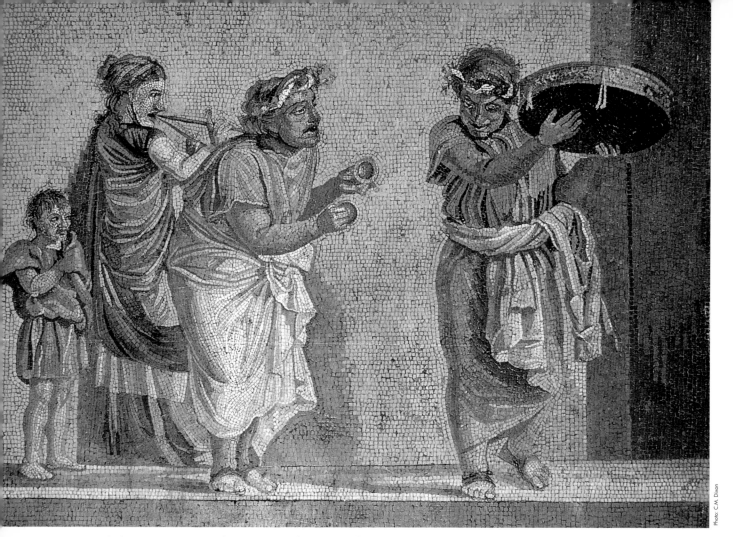

Masked actors as musicians in a play, Roman mosaic from Pompeii before A.D. 79 eruption, signed by Dioskurides of Samos, now at the National Archeological Museum in Naples

Some of the earliest known mosaics adorn the exteriors of buildings constructed during the third millennium B.C. at Uruk in Mesopotamia. There, in the fertile valley between the Tigris and Euphrates Rivers, the Sumerians embedded long terra-cotta cones into the surfaces of the walls and columns to protect the underlying structures and to decorate their surfaces with colorful geometric patterns.

Although it's impossible to date their earliest usage, it is known that mosaics made of pebbles were important features in the gardens of ancient China. Long before the birth of Christianity, the Chinese created mosaic pavements that were highly symbolic of the natural world around them. Each pebble was precisely arranged to maintain the overall balance of *yin* (the feminine forces of nature) and *yang* (the masculine) in the garden.

Most of the early mosaics combined functionality with surface decoration. In Gordium, a town not far from

Ankara, Turkey, archeologists have discovered pebble mosaic floors in houses built during the eighth century B.C. The pebbles were arranged in simple geometric patterns and set in an early form of mortar.

As the use of pebble mosaic floor coverings spread throughout the Greek-speaking regions of the ancient world, the designs became increasingly more refined. Floor mosaics produced in Olinthos (located in the Macedonian region of northern Greece) during the fifth century B.C. reveal intricate figures and patterns, and those created a century later in Pella, the capital of Macedonia, showed remarkably sophisticated rendering techniques. Smaller pebbles were set more closely together to achieve greater detail, and some of the pebbles were painted to increase the range of colors. Accentuating important features were outlines made of lead wire or thin strips of terra-cotta.

Roman mosaic with overall pattern, ca. 3rd century. The floor is level, but note the three-dimensional illusion. Now at the Prehistory Museum in Munich

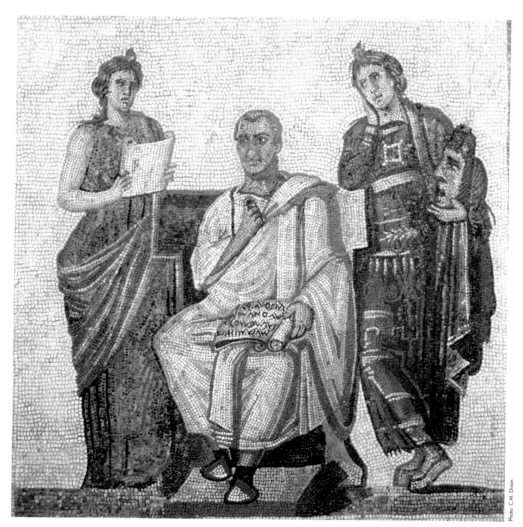

Roman mosaic of Virgil writing the Aeneid while being inspired by two muses, Clio and Melpomene, 2nd–3rd century, now at the Bardo Museum in Tunis.

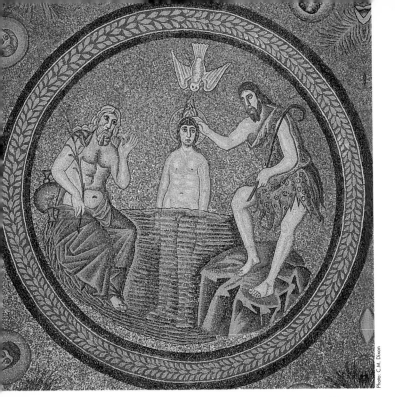

Christ's baptism in the River Jordan by John the Baptist, Arian Baptistry, Ravenna, 5th century Byzantine mosaic. The figure on the left is a pagan personification of the river.

Christ in the Katholicon, Monastery of Osios Loukas (St. Luke in Phocis), Greece, 11th century Byzantine mosaic

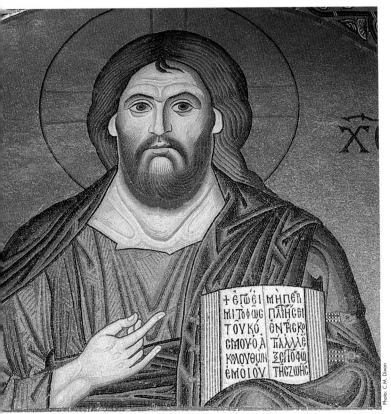

The Hellenistic period, dating from the reign of Alexander the Great (336–323 B.C.) to the first century B.C., witnessed the introduction and widespread adoption of a new mosaic material—natural stone cut into small pieces called *tesserae*. The triangular, square, or rectangular shapes of the tesserae could be fit together more closely than pebbles, and the resulting effects were more lifelike.

This newer method of creating mosaics with stone tesserae was enthusiastically embraced by the Romans, who used it with great dexterity in their homes and temples. Some of the earliest Roman works were created in Pompeii during the second or first century B.C. and were preserved in good detail by the eruption of Mount Vesuvius in A.D. 79.

As the Roman Empire expanded, demand grew for mosaic floors, and variations in style and composition developed according to region. Mosaicists in some areas such as the North African provinces continued to produce central *emblemata*—detailed representational compositions—within larger, more simplified mosaics. In other regions large overall patterns, often done in monochrome, were more common.

By the third century A.D., mosaics began to appear on walls as well as floors. Some of the Roman wall mosaics depicted sacred images, and this practice was soon adopted by the early Christians. The church of Santa Costanza, built in the mid-fourth century, shows evidence of a transition from one set of religious beliefs to another. Its wall mosaics contain some Old and New Testament scenes among the more prevalent pagan motifs.

Glass tesserae, which had been used sparingly on floor mosaics as early as the third century B.C., became increasingly common and ultimately dominated the early Christian mosaics. Similarly, gold tesserae (which were made by sandwiching pure gold leaf between layers of glass) had first been used by the Romans for secular images but rapidly became the accepted means for depicting light emanating from God.

The Byzantine Era, which lasted from the fifth through the 15th centuries, saw the greatest flowering ever known of mosaic as an art form. Mosaics no longer were confined to discrete panels but now covered entire walls and ceilings with images. Immense figures became important design elements and matched the scale of the surrounding architecture.

During the sixth century, the Byzantines began enhancing the reflective qualities of gold tesserae by setting

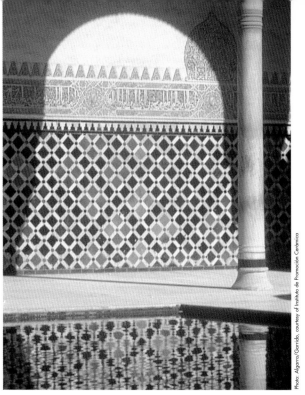

Geometric patterned mosaic of glazed ceramic tiles, the Alhambra, citadel of the Moorish Kings of Spain, Granada, completed during the 14th century

them at oblique angles. Golden haloes set in this manner appear to shimmer with light, in stark contrast with the dull stone tesserae used for the saints' faces.

While early Byzantine mosaics reveal significant classical influences toward realism, later works look more like icons: the figures appear practically motionless on a field of gold tesserae. Another evolution in style was the use of lines of color to model the faces and garments of the subjects.

The fall of Constantinople to the Turks in the middle of the 15th century signaled the end of Byzantium, and with it died the rich environment that had nourished the art of mosaic for a millennium. As the Renaissance took hold, particularly in Italy, there was a renewed interest in pictorial realism and a rejection of the use of gold so common to mosaics. Mosaics continued to be used in church decoration, but they increasingly began to imitate contemporary painting.

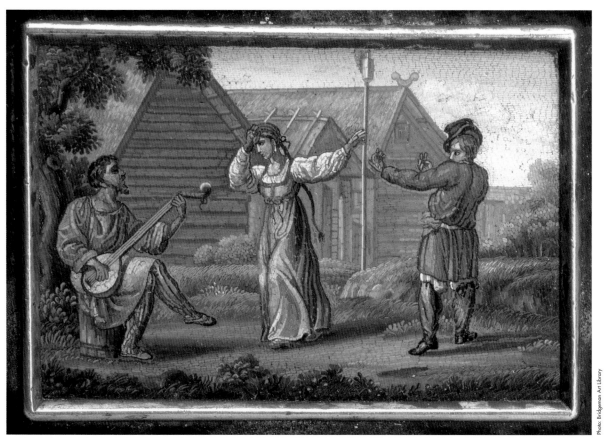

Russian Dance, by Yegor Yakovlevich Vekler (1800–61), ca. 1830 (mosaic), Hermitage, St. Petersburg/Bridgeman Art Library, London. Reproduction permission required for CD-ROM use

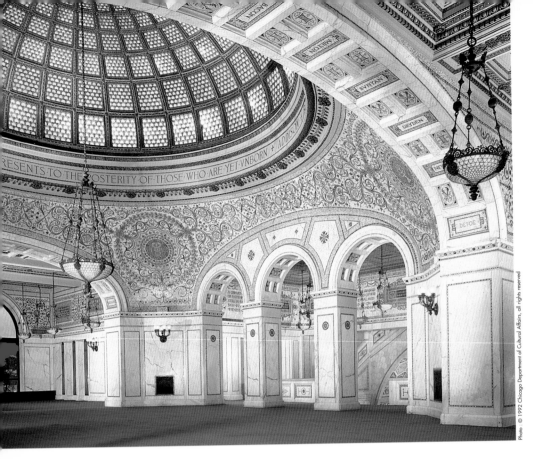

Above: Mosaic scrolls and rosettes complement the 38-foot Tiffany dome in Preston Bradley Hall, Chicago Cultural Center, 1892–97.

Below: Detail of rosette, Preston Bradley Hall

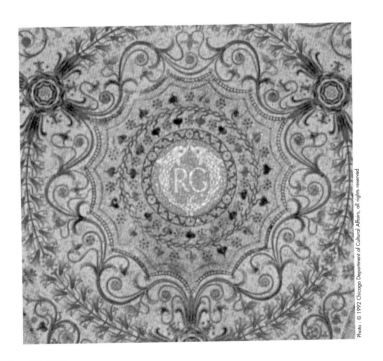

During the 15th and 16th centuries, great Italian painters provided "cartoons" for others to construct as mosaics. Some artists, including Titian and Tintoretto, went so far as to have early Byzantine mosaics (which they characterized as old and ugly) removed from St. Mark's Basilica in Venice and replaced by their more "modern" works. At St. Peter's in Rome, the dome was decorated with mosaics done from the cartoons of Cavalier d'Arpino, and exquisite mosaic reproductions of 16th and 17th century masterpieces were installed at the altar. The Venetian and Vatican workshops, established to complete and maintain the mosaics in St. Mark's and St. Peter's, subsequently became major European centers for mosaic production.

In the 18th and 19th centuries, mosaics took an odd turn into the world of miniatures. The Vatican workshops began producing *smalti filati*, threads of opaque glass, which were cut into tiny cubes, rectangles, and other shapes. These minute tesserae were assembled by hand into micromosaics, which were subsequently incorporated into snuff boxes, plaques, and jewelry to be sold to tourists.

As the 19th century gave way to the 20th, the rise of the Art Nouveau movement rekindled interest in mosaics. Antoni Gaudí, an innovative Spanish architect, took the unusual step of placing mosaics on exterior rather than interior walls of buildings. Working primarily in Barcelona, he created startling new architectural forms, many of which he covered with outer skins of mosaic. Gaudí was influenced by the Moorish tradition of glazed tile mosaic, but he improvised designs using fragments of tiles, bits of rubble, and other *objets trouvés*.

In 1938 Raymond Isidore, a foundry worker, road crewman, and cemetery caretaker in Chartres, France, began

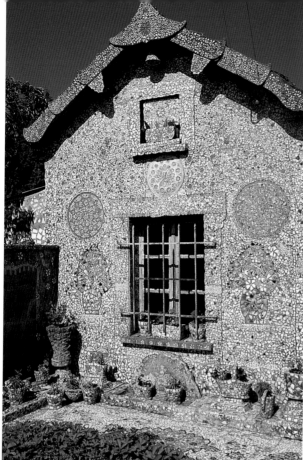

Photo: Dana Irwin

Left: Raymond Isidore (1900–1964), mosaic covering one facade of Maison Picassiette, Chartres

Below: Courtyard garden at Maison Picassiette, completed ca. 1962

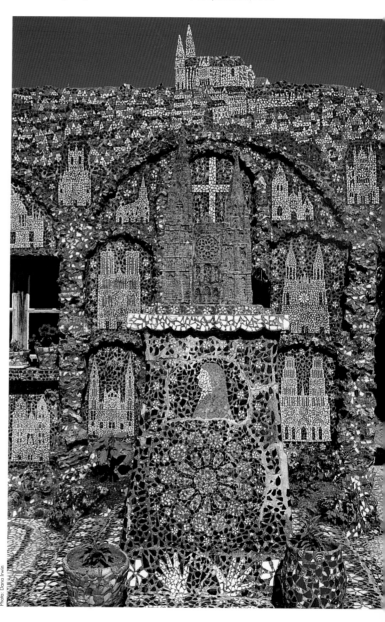

Photo: Dana Irwin

the mosaic work that would ultimately cover every interior surface of his house—including its furnishings—the exterior walls, garden structures, and a separate chapel. Because he used discarded bits of glass and broken dishes, his neighbors mocked him with the title *Picassiette*, which loosely translates as "plate stealer." Their motives were ungenerous, for the term *piqué* implies "crazy" or "loony," and to refer to someone as *un pique-assiette* is to call him a parasite or sponger. Isidore was undeterred by the scorn, however, and his remarkable creations so inspired succeeding mosaic artists that they call their own work pique assiette.

Thanks to the abundant traditions from which they may draw, today's mosaic artists enjoy complete freedom of expression. Once learned, the basic techniques for making mosaics can be applied equally well to formal compositions or purely abstract patterns. Even the simplest designs bring immense satisfaction, whether they cover a small item or an entire building.

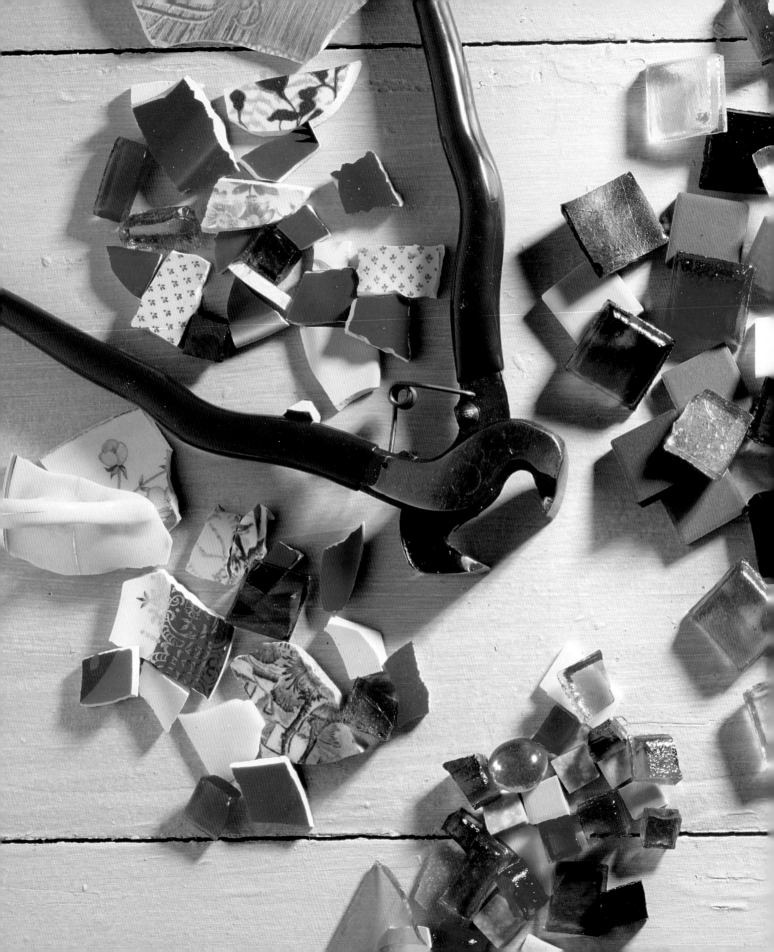

GETTING STARTED

Although the finished product looks sophisticated and complex, the process of making a mosaic is quite simple and requires only a minimum of tools and materials. You'll find that many of your favorite materials are inexpensive—sometimes even free—and readily available. Beginners and professionals alike create exquisite designs with broken tiles, pieces of stone, and other castoffs they obtain for little or no money.

Similarly, a good set of tile nippers is the greatest investment you'll need to make in the way of tools. With those and a few other handy gadgets, you'll be creating your own lasting mosaics in no time.

Materials

Tesserae

Tesserae are the many small units that are assembled into larger, more significant designs to create mosaics. The words tessera (a single unit) and tesserae (more than one) are Latin terms for "cube(s)" that derived from the Greek word *tesseres*, meaning "four-cornered." Originally used to describe the small cubes of stone or glass that composed ancient mosaics, these terms make convenient labels for any mosaic units—be they marble, ceramic tile, or broken crockery—and are equally appropriate for contemporary mosaics.

Although it's safe to say that nearly any solid material, from bits of fabric to pieces of macaroni, can be used to create mosaics, this art form generally has been applied to more permanent constructions. In fact, one of the most satisfying aspects of mosaics is that you can literally walk on them, and they will still look just as glorious when your grandchildren follow in your footsteps. Many of the commonly used materials are described here, but don't let this list limit your creative instincts. By their very nature, mosaics encourage experimentation with all manner of materials and designs.

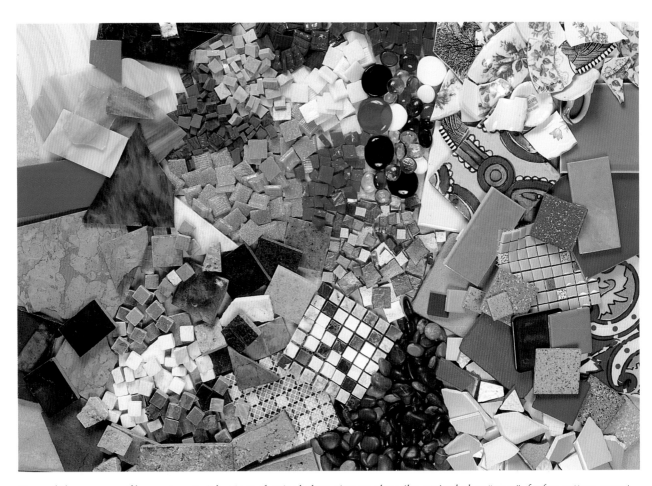

Some of the many possible mosaic materials: pieces of stained glass; vitreous glass tiles; stained glass "gems"; broken pottery; precut marble and granite tiles; pieces of slate, limestone, and marble; gold leaf glass tiles; pebbles; glazed and unglazed ceramic tiles

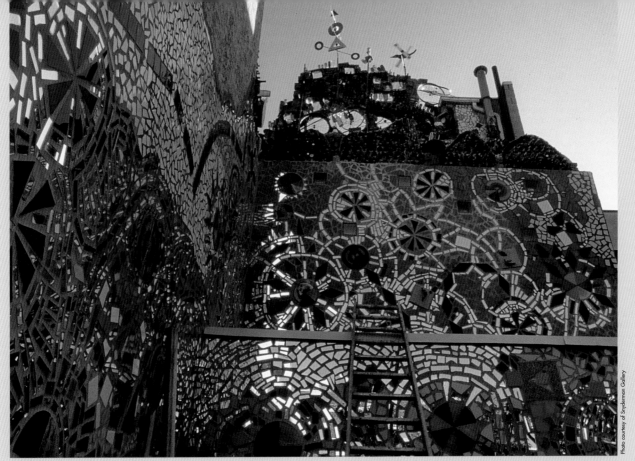

Isaiah Zagar, exterior walls of the artist's Kater Street Studio in Philadelphia, tile and mirror mosaic, 1995

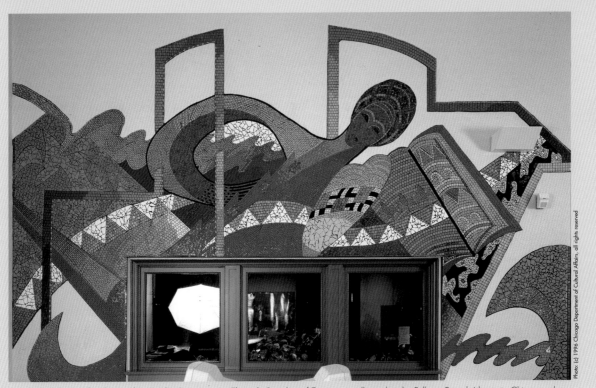

Nina Smoot-Cain and Kiela Songhay Smith, *Come Journey Through Corridors of Treasures*, wall mural at the Pullman Branch Library in Chicago, glass and ceramic tile, 9'3" x 15'7" (2.8 x 4.7 m), 1995

Kathryn Schnabel, *Genesis, de Ponte,* stained glass and grout, 36" x 24" (91.5 x 61 cm), 1995

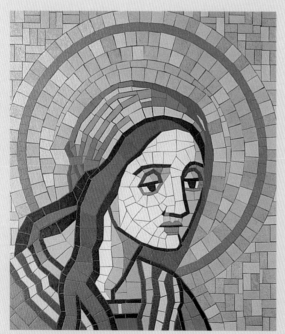

Sven Warner, *Mary Magdalene at Deposition,* paint-saturated fabric, 29½" x 26" (75 x 66 cm), 1992

Stone

Stone was once the dominant material for making mosaics, beginning with the uncut pebbles used thousands of years ago by the Greeks. Although their palette was limited to a fairly narrow range of earth tones, the ancient Greeks were able to create pebble mosaics of astounding beauty and refinement. Pebbles are still used today but by relatively few artists. It's not an easy task to find (and handle) large quantities of well-shaped pebbles in uniform sizes and in a range of tones. By strolling along a beach or riverbank, however, you can accumulate a modest collection of interesting pebbles fairly quickly. Judicious use of even a small batch of pebbles together with some cut stone can result in a stunning composition.

In addition to collecting your own stones or cutting chunks from the thick slabs sold for landscaping purposes, you can purchase some of the most popular types of stone in easy-to-use precut tiles. Foremost among these is marble, which is available in a wide assortment of earth tones plus shades of white and black. Because of its variations in color and random veining, no two pieces are identical. Unpolished marble is more natural looking, but it's quite porous and susceptible to damage from moisture if left unsealed. Large pieces of green marble have been known to warp after prolonged exposure to dampness.

Granite is a denser stone than marble and has more regular mottled patterns. It too comes in a range of earth colors. When used in concert, marble and granite complement each other nicely. Granite has a greater tendency to shatter when cut, however, and isn't as easy to use as marble for making mosaics.

A third type of stone tile is slate, used mainly for floors, patios, and walkways. Although its color range is limited to black and gray tones, its strong linear quality can be quite useful in some applications.

Marble and granite tiles are available in small squares, ranging from ⅝" (1.5 cm) to nearly 2" (5 cm), and in larger sizes up to 12" (30.5 cm) square. Slate tiles come in both square and rectangular formats of various sizes.

Glass

Glass tesserae are some of the most highly prized mosaic materials due to their reflective qualities and the wide range of colors available. Stained glass and other types of translucent colored glass make handsome mosaics, especially when applied to a surface that allows the

light to shine through. More common, though, are opaque glass tiles that are prefabricated specifically for mosaics.

Vitreous glass (also called Venetian glass) is machine-molded into thin square tiles with a smooth surface on the face and slightly beveled edges underneath. The smaller underside is often grooved but can be smooth, depending on the manufacturer. When used full size, the grooves and beveled edges provide additional adhesion, but sometimes they're a hindrance when you're cutting the tiles into smaller sizes. Vitreous glass tiles come pasted onto sheets of paper or plastic mesh and can be ordered unmounted. They're available in various sizes but are most common in ¾" (2 cm) squares about ⅛" (3 mm) thick. Vitreous glass is available in a wide range of colors, including some with metallic veins of gold or copper. It's frost proof, extremely durable, and stain resistant.

Smalti are handmade glass tesserae produced in relatively small quantities according to classic Venetian traditions. Molten glass, colored with metallic oxides, is pressed into large slabs about ⅜" (1 cm) thick, then split by hand into small rectangles. The uneven, cut side becomes the face of each piece, producing a brilliant surface unparalleled by other materials. To make gold and silver smalti, a thin sheet of metal leaf is sandwiched between two layers of glass, and the whole assembly is fused together. In addition to gold and silver, smalti are available in a full range of colors. They're sold in bulk or face mounted on kraft paper, and, although sizes vary, the most common is ⅜" x ½" (1 x 1.5 cm).

Ceramic Tesserae

Available in a vast assortment of glazed and unglazed surfaces, ceramic tesserae represent probably the most versatile of materials. Prefabricated tiles are readily available in a multitude of sizes and shapes. They range in color from pale pastels to fully saturated primaries and include many variations that suggest stone and other natural materials. Unglazed tiles carry their color all the way through and are especially convenient because they can be oriented however desired. Glazed tiles have a thin coating of color—glossy or matte—over an off-white base.

Ready-made objects such as dinnerware, vases, and bowls offer additional sources of ceramic tesserae. These can be shattered into random sizes and configurations or cut by hand into specific shapes. Many of the resulting tesserae are curved not flat, and some contain three-dimensional decorative elements. These produce highly tex-

Ron Gasowski, *Black Madonna*, black glass, 28" x 26" x 11" (71 x 66 x 28 cm), 1988

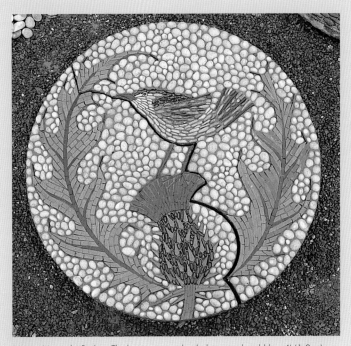

Maggy Howarth, *Bird on Thistle*, inset in a school playground, pebbles, 4' (1.2 m) diameter, 1994

To mix your own mortar, combine two parts sand, one part Portland cement, and one part latex additive or water.

The consistency of your mortar should be thick but smooth.

tured surfaces that often contain elements of humor.

Backing Boards and Other Bases

Many types of bases are appropriate for mosaics, and your choice for each project will be determined mainly by how and where you plan to use it. If you're installing your mosaic where it frequently will be exposed to wetness—outdoors, in a shower, on a kitchen counter top—the base must be waterproof so that it doesn't absorb moisture and cause the adhesive to fail. In dry settings, mosaics can be mounted directly onto walls and innumerable sculptural objects.

When making small, free-standing flat mosaics, you'll need a backing board. The optimum choice is a cement backer panel, which consists of a thin layer of concrete that is reinforced by a plastic woven mesh on the top and bottom surfaces. A skim coating of cement covers the mesh on both sides. The slightly rough surface bonds extremely well with cement mortar and acrylic-based tile adhesives. Cement backing boards come in ¼" (6 mm) and ½" (13 mm) thicknesses and are strongly recommended for installations where dampness is a factor. They can be cut to shape using a jigsaw with a tungsten carbide blade or scored with a blade and broken.

Exterior-grade plywood is a popular choice among mosaic artists, and some use high-density particle board. Both have problems with warping and delamination and must be thoroughly sealed on every surface before use. Untreated wood absorbs moisture from the adhesive and the ambient air. The smooth face of the board should be scored with a sharp knife or hacksaw blade before sealing to provide some "tooth" for better adhesion of the mosaic.

Adhesives

Ask any two mosaicists what adhesives they use, and they're likely to give two different answers—and both will be equally emphatic about their choices. Among the many possibilities, some adhesives are temporary and others permanent.

Temporary adhesives such as wallpaper paste, flour paste, and wheat paste are all water based and hold a mosaic face down on a sheet of kraft paper or plastic mesh until it can be installed permanently (the indirect method of constructing a mosaic). The paper or mesh is removed afterward by wetting it with warm water. Some artists substitute a clear adhesive film, which can be peeled off fairly easily.

There are three major types of permanent adhesives—acrylic compounds, thinset cement-based mortar, and epoxy resins. Acrylic adhesives range from PVA (polyvinyl acetate), which is a thin white craft glue sold under many trade names, to multipurpose latex-based tile adhesive, also called mastic in the trade. Acrylic adhesives can be used for interior installations on most surfaces and are especially recommended for use on plywood because of their lower moisture content. They can be cleaned up with soap and water while still wet but must be scraped off or removed with a solvent after setting up.

Mortar is a combination of sand, Portland cement, and water that can be used for interior or exterior installations of stone, glass, and ceramic mosaics. Mortar mixes used for mosaics and tile installations are called "thinset" because the amount required is quite thin in comparison to that needed for heavier applications such as brick laying. Some brands of thinset mortar contain a polymer additive, which improves their strength and flexibility. After mixing, cement mortar should have a thick, smooth consistency similar to heavy mud.

Kathryn Schnabel, *Reach and Receive*, stained glass and grout, 19" x 22½" (48.5 x 57 cm), 1995

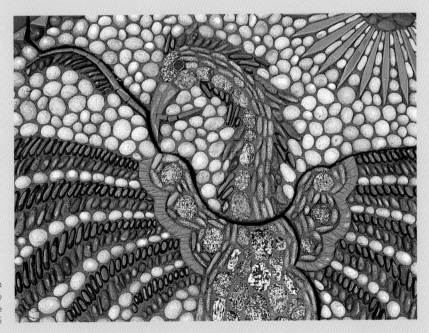

Maggy Howarth, detail of a Chinese phoenix design, pebble mosaic in a private garden, entire work is 5' (1.5 m) square, 1995

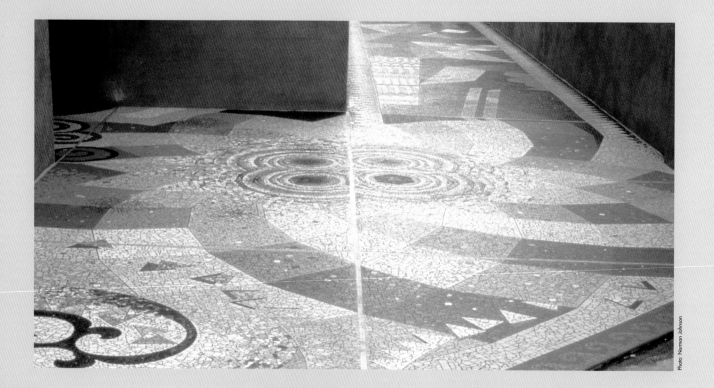

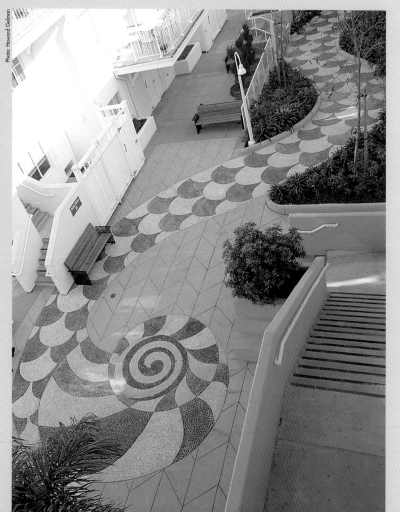

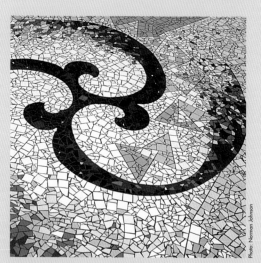

Top: Robert Stout, section of *The Pathway, II*, Albuquerque Museum, ceramic tile, entire work is 35' x 35' (10.7 x 10.7 m), 1993

Above: Detail of *The Pathway, II*

Shelby Kennedy, *La Serpiente*, pathway at Plaza del Sol in San Francisco, pebbles, 8' x 110' (2.4 x 33.5 m), 1994

Epoxy resins vary widely in their chemical properties, but all consist of at least two components, a resin and a hardener, that must be mixed immediately prior to use. Epoxies are extremely strong and may be the only adhesive of choice when working on especially difficult surfaces such as some metals. It's also recommended when installing large pieces of green or white marble, which have a tendency to warp or stain when applied with water-based adhesives. Compared to others, epoxy adhesives have a short working time before setting up and are quite expensive.

Grouts

Grout fills the crevices between tesserae, adding considerable strength and durability to the construction. Grout joints also bring a linear quality to the design that enhances its flow. All grouts contain Portland cement and some are polymer enhanced for greater strength and flexibility. Nonsanded grout can be used for joints up to ⅛" (3 mm) wide, and this is the preferred material for any tesserae that are easily scratched. Use sanded grout for larger joints and for dense-bodied (less porous) materials. Both sanded and nonsanded varieties are available in a range of dark and light colors.

Among mosaic artists, the procedure for mixing grout is almost as contentious as the choice of an adhesive. One school of thought calls for slowly adding the dry powdered grout to a small amount of water. The alternate approach is to place the grout in a mixing container, make a well in the center, then slowly add the water. Whichever method you choose, you should aim for a thick, fairly dry mix with a smooth consistency. To avoid getting lumps, sift the powdered grout before mixing it.

Cleaners

After grout is applied to a mosaic, the excess is removed with a barely damp sponge, and the surface of the mosaic is polished with clean, dry rags to remove any haze. If you're not persistent enough in cleaning, a thin film of grout may remain on your mosaic after it's dry. This can be removed using a dilute solution of hydrochloric acid, which is sold commercially as tile or patio cleaner at hardware and home supply stores. Like all acids, this material is caustic and should be avoided if possible. If you do use it, be sure to wear safety glasses and rubber gloves.

Tools

Tile Nippers

As their name suggests, tile nippers are designed to cut ceramic tiles into square, round, and irregular shapes. They're also very effective at cutting glass and stone tiles up to about ¼" (6 mm) thick. A good set of nippers is the single most important tool you'll need to create mosaics, and it's worthwhile spending a little extra to get a set that cuts easily and sits comfortably in your hand. Well-designed nippers have spring-action handles and tungsten carbide cutting edges. The best and most costly models have replaceable carbide jaws and compound leverage, which makes cutting easier.

When using nippers, place the cutting jaws so that they overlap the edge of the tile by about ⅛" (3 mm). Then squeeze the handles firmly and evenly. A cut made into the smooth, manufactured edge of a molded glass or ceramic tile is always more difficult than one made into a rough edge that has already been cut. To make a tessera with a curved edge, make several small "nibbling" cuts rather than one or two large ones.

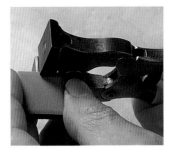

When using nippers, position the blades so that they overlap the tile by only about ⅛" (3 mm).

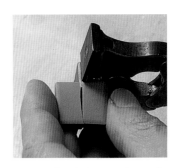

Squeeze firmly but evenly on the handles.

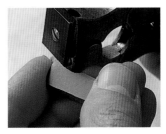

To make a concave curve, nibble small pieces from your initial cut.

With practice, you can cut any curve you may need.

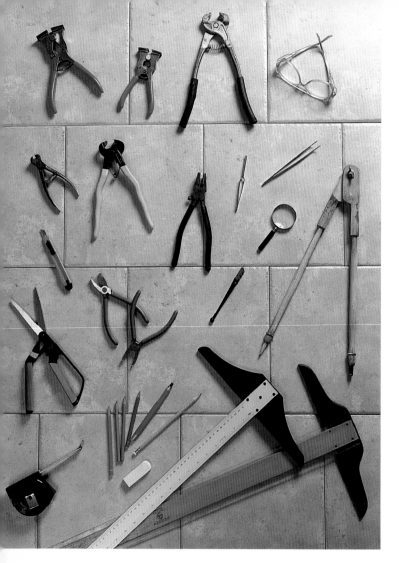

When designing and creating your mosaics, choose the tools that feel the most comfortable. Shown above are: 7" (18 cm) nippers, 5½" (14 cm) nippers, 10" (25.5 cm) nippers, safety glasses, 5" (12.5 cm) nippers, 8" (20.5 cm) nippers, running pliers, two types of tweezers, magnifying glass, scissors, craft knife, wide- and narrow-jawed breaking pliers, glass cutter, compass, tape measure, pencils and eraser, T-squares.

Hammer and Hardie

Some artists prefer using a hammer and hardie, the traditional tools of European mosaicists, especially when cutting smalti (which chips and shatters fairly easily) and thicker pieces of stone. A mosaicist's hammer has an unusual curved head with sharp, wedge-shaped edges on both ends, and a hardie is a wide chisel blade with an attached shaft for mounting into an anvil. A mosaicist's hammer and hardie can be obtained only from specialty suppliers, but reasonable substitutes can be purchased at a well-stocked hardware store. Look for a masonry hammer and a blacksmith's hardie, preferably with sharp, carbide edges. Then embed the shaft of the hardie into a can of concrete or the sawn-off end of a thick log.

Other Cutting Tools

Tile pliers are used to cut larger tiles into small pieces. A tungsten carbide cutting wheel scores a breaking line on the surface of the tile; then the tile is placed, scored side up, between the pliers' anvil and separator. As the pliers are closed, the tile separates along the scored line.

If you plan to include stained glass in your designs, be sure to purchase a glass cutter. This stick-shaped tool has a small metal wheel that scores the glass, allowing it to be broken along the score. The metal ball at the other end of the tool can be used for tapping the glass on the underside of the score to encourage the break.

When cutting multiple strips of stained glass, running pliers come in handy. These have one concave jaw and one convex jaw that, when placed directly at the score line and squeezed together, can carry the break a good distance. If desired, use narrow-jawed breaking pliers to grip the glass as you cut the strips into small tesserae.

More elaborate studios may include a wet saw for cutting large pieces of stone or thick tiles into smaller shapes that can be handled with nippers. A wet saw has a diamond-tipped blade, bathed in a constant flow of water, that cuts through the hard surface without chipping it.

At the other end of the spectrum are scissors and a sharp craft or mat knife. These are essential for cutting paper and adhesive film and for innumerable other tasks.

Trowels, Floats, and Similar Tools

Notched trowels are the tools of choice for spreading adhesive onto a backing board or other flat base. These are generally rectangular in shape, with square or V-shaped notches of various sizes. As the trowel is wiped across the adhesive, the notches create a uniform, ridged bedding for the tesserae. Larger, heavier tesserae require larger notches for a thicker layer of adhesive.

Unnotched trowels, both square and pointed, are available in a variety of sizes. Smaller smooth trowels are used to "butter" the backs of tesserae with a thin layer of adhesive, and the larger ones are handy for mixing mortar and smoothing it over a wide expanse.

Palette knives and small spatulas are equally useful for mixing, applying adhesive, and budging tesserae into position.

Rubber floats look like trowels in their general shape, but instead of a thin metal blade they have a thick rubber surface. The sponginess of the rubber makes it ideal for pressing grout into the crevices between tesserae.

Other tools that may be used for applying grout include flexible plastic grout spreaders and small pieces of polyethylene foam wrap. The latter is a packing material that works especially well on curved surfaces.

Safety Items

Whenever you're cutting tesserae, no matter how few you need to cut or what tools you're using, be sure to protect your eyes with safety glasses or goggles. A protective dust mask or respirator should be worn when working with dry cement mortars and grouts. These contain silica sand, which irritates your lungs and breathing passages. Latex or rubber gloves are recommended when working with grout and cement.

Miscellaneous Other Tools

Paper and pencil are needed for sketching your mosaic designs, or you can plan them on a computer. To trace a pattern onto a smooth working surface, carbon paper and a blunt pencil work well. Rough surfaces are a bit more challenging. If you don't want to transfer the design freehand, you can use a tracing or pouncing wheel (used to mark fabric for sewing). As you trace the lines of your sketch, the small toothed wheel pierces the paper. Continue holding the paper in place and retrace the lines with a piece of soft charcoal. This produces dotted lines from which to work.

Tweezers, dental probes, and other long, thin tools are useful for positioning small tesserae more exactly.

Keep an assortment of mixing bowls, buckets, and cleanup tools handy as you work. Mixing bowls and other containers are needed for preparing grout and cement mortar. To clean the grout haze from the surface of your mosaics and the material from your tools, you'll need a ready supply of clean water, one or two good sponges, and plenty of lint-free rags. Nearly all of the materials are water soluble when they're fresh, so it's best to clean off your tools as soon as you're finished with them.

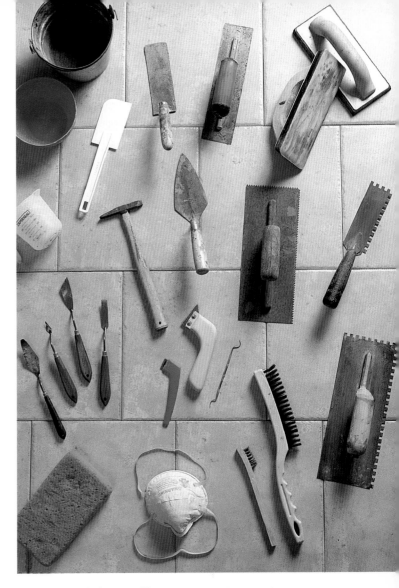

Some basic tools for assembling mosaics: mixing containers, spatula, small margin trowel, flat steel trowel, hard and spongy rubber grout floats, measuring cup, carbide-tipped masonry hammer, small pointing trowel, ⅛" (3 mm) V-notched trowel, ¼" (6 mm) square-notched margin trowel, various palette knives, two sizes of grout saws, dental probe, sponge, dust mask, wire brushes, ¼" (6 mm) square-notched trowel

If you've allowed the grout to set up a bit too thoroughly and the joints are higher than you'd like, you may need to use a stiff metal brush or a grout saw to adjust them. A grout saw is also useful for removing a misplaced or broken tile after the grout has dried completely. Saw back and forth until the tessera is bonded only at the bottom; then hit it lightly with a chisel.

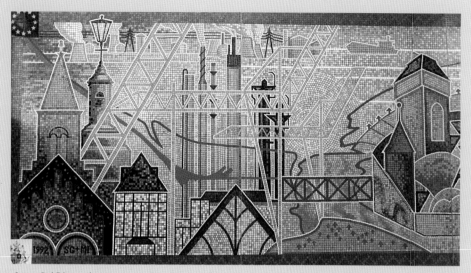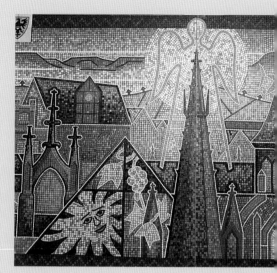

Susan Goldblatt and Magnus Irvin, *Twin Towns*, wall mural at the Port Arcades Centre in Ellesmere Port in Cheshire, England, vitreous glass, 9' x 60' (2.6 x 17 m), 1992

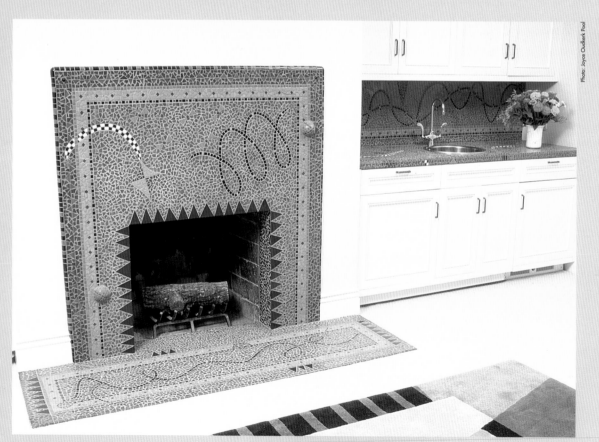

Karen Thompson, fireplace and wet bar in a private residence, ceramic tile, 1994

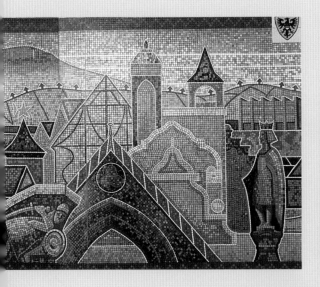

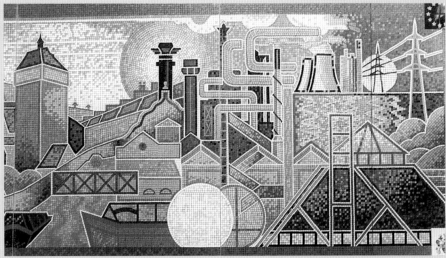

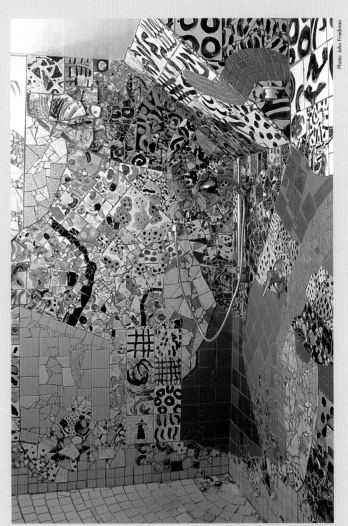

Chere Lai Mah and Susan Wick, hand-painted tile, shower area in residential bathroom, 1994

Detail of bathroom wall

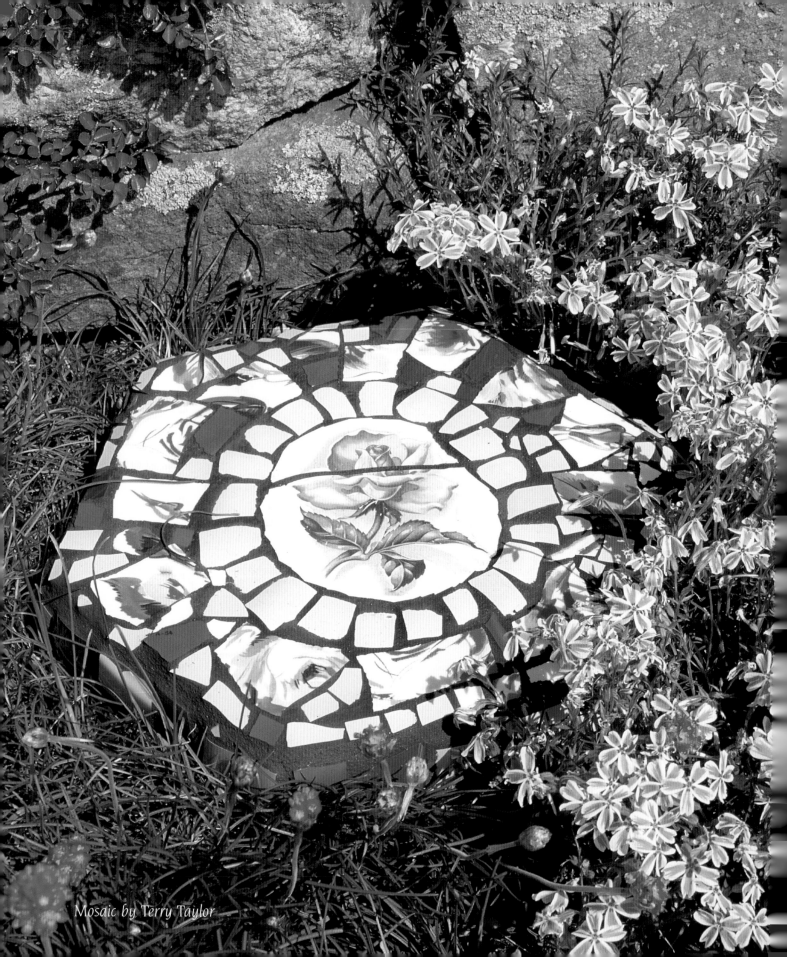

Mosaic by Terry Taylor

PIQUE
ASSIETTE

If you're a collector at heart or someone who can't pass a flea market without stopping in to look, then you're an ideal candidate for pique assiette. Literally translated as "stolen plate," this technique produces colorful, robust mosaics using bits and pieces of imperfect heirlooms, either purchased or inherited. In fact, the works themselves are often called *memoryware* because of their strong connections to our daily lives.

There are few rules to this approach, and you can easily incorporate all manner of found objects and collectibles into your mosaics; just make sure to use a compatible adhesive. Once you've settled on the materials and the surface you want to cover, you can make the finished design as open ended or as preplanned as you wish. The results are so immediately satisfying that you may decide just to let each piece develop as you go.

A simple project to start with is a precast stepping stone that's covered in a mosaic made of inexpensive dinnerware. (Secondhand shops, flea markets, and garage sales are good sources.) Items that are chipped work just as well as perfect ones, and they're much cheaper. In addition to a selection of colorful plates, you'll need a few simple materials and tools to start your mosaic: dry cement mortar, a mixing container, large and small spatulas, and a pair of tile nippers. If desired, protect your work surface with plastic sheeting.

One approach for obtaining small pieces from whole plates is to drop the dishes on the floor or smash them with a hammer, then work with the irregular shapes that result. Just for the sheer pleasure of it, everyone should try this at least once.

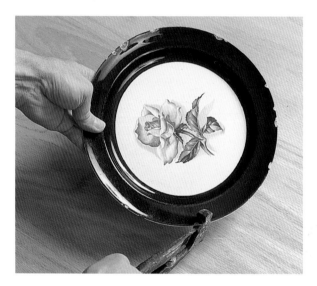

For a bit more control, use tile nippers to whittle each plate into workable pieces. Keep in mind that you'll never have complete control over your cuts. No matter how good your tools, nor how experienced your hand, the materials themselves instill some randomness in the process. Always protect your eyes by wearing safety glasses or goggles when nipping or smashing your materials.

With your first cut, try to remove a small piece of the outer rim. This cut tends to be unpredictable and may bisect the beautiful pattern you want to use in the center of your mosaic. Don't let this deter you; the crack may actually enhance your design.

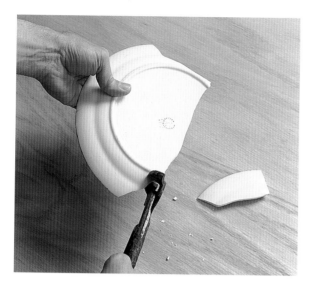

After the first cut, turn over the plate and begin removing the outer rim in segments. Don't worry about the size of your pieces; you'll cut them more exactly later. When making your cuts, remember to place the nippers so that the blades extend only about ⅛" (3 mm) onto the plate.

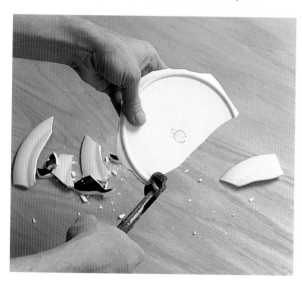

Nibble small bits off the lip on the underside of the plate, saving the rounded pieces for another project. (On a mosaic that will be underfoot, it's best to use flat materials

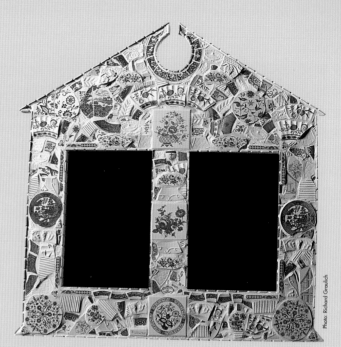

Zoe and Steve Terlizzese, *Blue & White Colonial Double Mirror*, broken china, 34" x 34" (86.5 x 86.5 cm), 1996

Photo: Richard Graulich

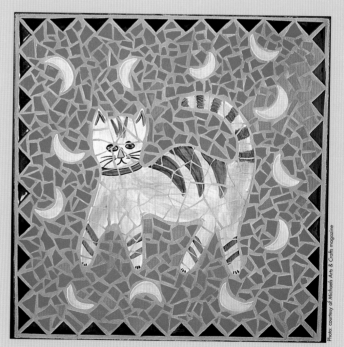

Karen Barnett, *Cat with Moons*, hand-molded and shattered ceramic tile, 26 x 26" (66 x 66 cm), 1995

Photo: courtesy of Michaels Arts & Crafts magazine

Above: Roberta Kaserman and Gary Bloom, composite photo of counter top at Café Maya in Alamosa, Colorado, ceramic tile, 11" x 28" (28 x 71 cm), 1994

Below right: Entryway of Café Maya, ceramic tile, 1995

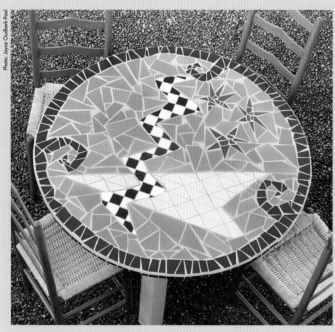

Photo: Joyce Oudkerk-Pool

Karen Thompson, *Jamaica Table*, ceramic tile, 48" (122 cm) diameter, 1991

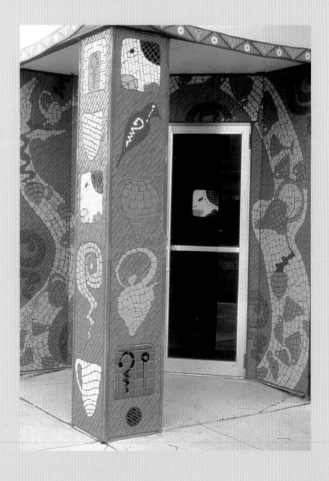

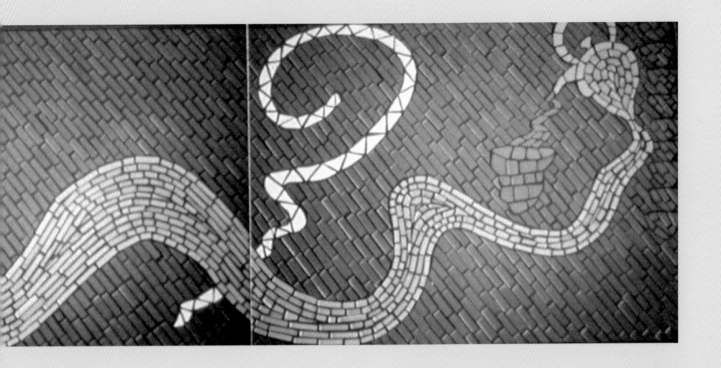

Photo: Evan Bracken

Debby Hagar, *Untitled*, vitreous glass and glass gems,
18″ x 32″ (45.5 x 81.5 cm), 1996

Photo: Stephanie Jurs

Robert Stout, detail of *Daphne*, wall mural at Plants of the Southwest, a nursery in Santa Fe,
New Mexico, ceramic tile and smalti, entire work is 48″ x 44″ (122 x 112 cm), 1995

throughout.) What remains is the central motif, which can be left in a single large piece or trimmed smaller as desired.

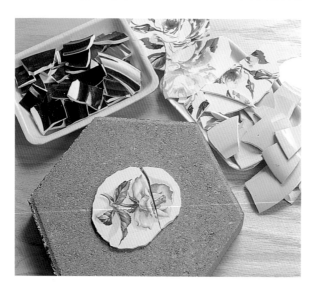

Repeat the process with several more plates to obtain patterned pieces and solid colors. For your own convenience later, sort your pieces according to color.

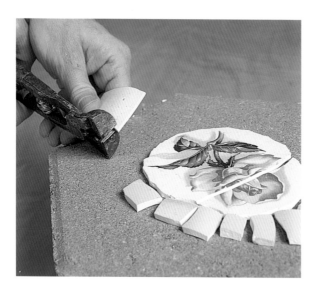

Place the stepping stone onto another paver or similar object to elevate it from your work surface, making it easier to reach all sides as you create your mosaic. Then begin assembling the pattern of your design. If you're working with a single large motif, start in the center and work outward. Cut small working tesserae by nipping off the fine outer edges of the plates wherever they occur. This will give an even thickness to all your pieces.

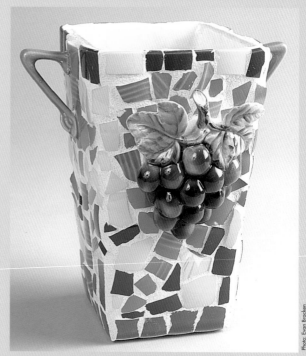

Terry Taylor, *Carmen Miranda Vase*, broken china and ceramic fruit (bananas are on the reverse side), 7" x 4¼" x 4¼" (18 x 11 x 11 cm), 1996

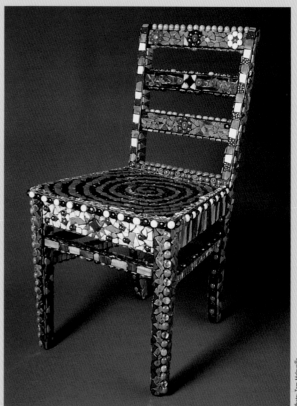

Laurel Neff, chair covered with stained glass, glass gems, and marbles, 36" x 16" x 16" (91.5 x 40.5 x 40.5 cm), 1993

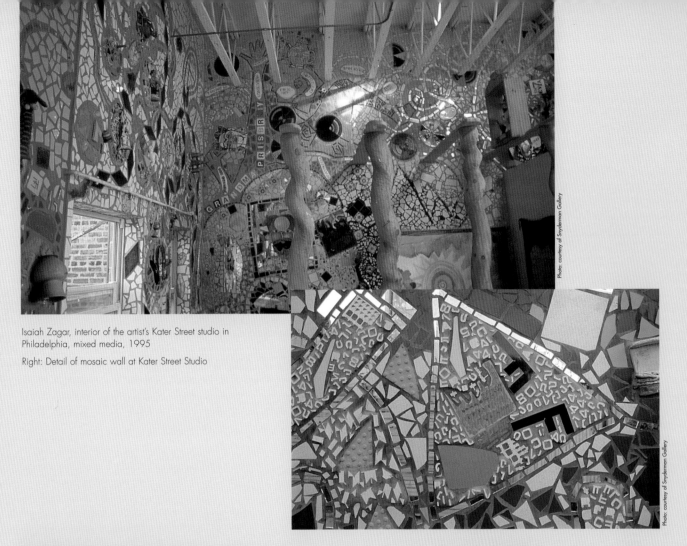

Isaiah Zagar, interior of the artist's Kater Street studio in
Philadelphia, mixed media, 1995

Right: Detail of mosaic wall at Kater Street Studio

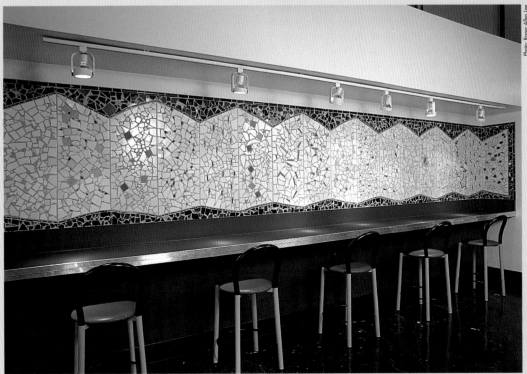

Twyla Arthur, wall mosaic at the
Golden Bear Café in Berkeley,
California, ceramic tile, mirror, and
found objects, 3' x 18' (.9 x 5.5 m),
1994

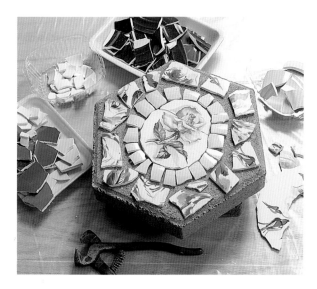

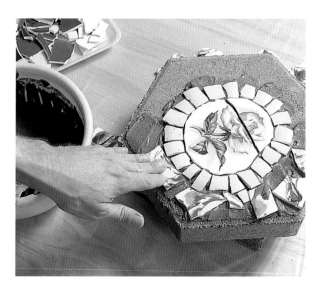

Continue cutting and placing tesserae until you have the main aspects of your design assembled in a satisfactory "dry run." You needn't have everything in place, just the important pieces.

When placing the tesserae, be sure to leave spaces between them for the grout. The size and regularity of the grout joints strongly influence the overall feeling of your design. Some artists prefer to minimize grout, and others use it boldly as an important design element. With pique assiette, uneven spaces complement the irregular shapes of the tesserae. Use the small spatula to remove any excess mortar that squeezes up to fill the grout joints.

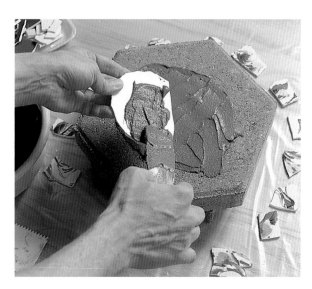

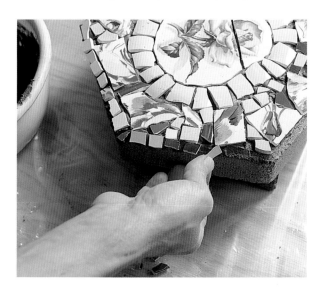

Mix the cement mortar as instructed by the manufacturer, starting with about a cupful of cool water and adding sufficient dry mortar to produce the consistency of thick mud. While the mortar cures briefly, remove the tesserae from the paver and set them aside. Then spread a ⅛" (3 mm) coating of mortar onto the center area of the stepping stone. Place the central pieces of the design, lightly buttering the backs of the tesserae with some mortar beforehand to ensure adhesion.

Continue with the design, spreading mortar and placing tesserae in small areas at a time. When all the larger pieces have been set, begin filling in with smaller tesserae. The beveled edge on this paver is neatly accented with a single line of small pieces.

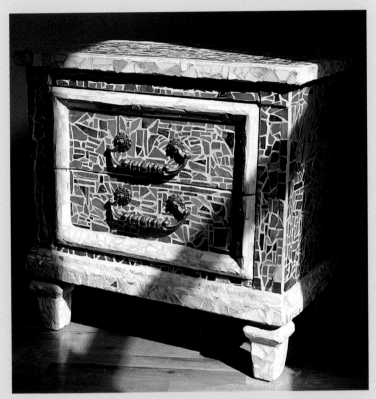

Chris Carbonell, end table covered with found materials, 26" x 26" x 12" (66 x 66 x 30.5 cm), 1987

Photo: Johnny Davis

Elizabeth Raybee, *We Didn't Know What to Say*, broken ceramic materials, 26" x 16" (66 x 40.5 cm), 1993

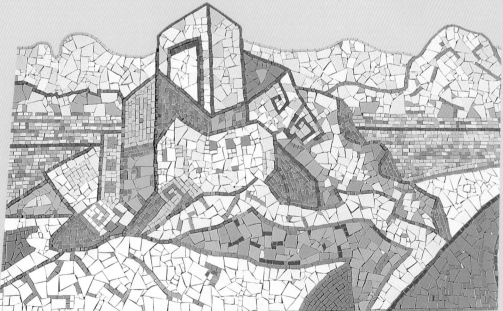

Peter Columbo, detail of untitled wall mural before installation and grouting, private residence in Boca Raton, Florida, smalti and handmade ceramic tile, 3' x 10' (.9 x 3 m), 1995

Photo: Robert Blosser

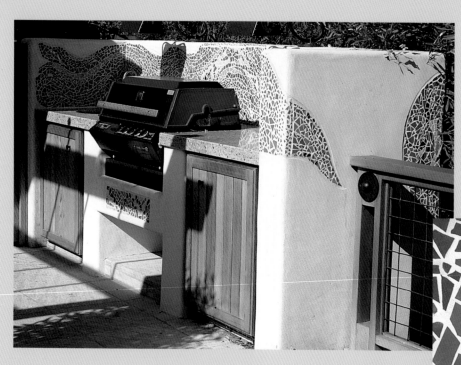

Left: Alison Cooper, barbecue surround at private residence, ceramic tile, 18" x 17' (.5 x 5.2 m), 1992

Below: Detail of barbecue surround

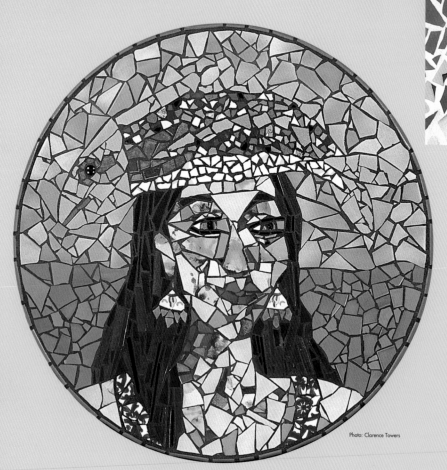

Photo: Clarence Towers

Elizabeth Raybee, *The Woman Who Mistook Her Fish for a Hat*, ceramic materials, 28" (71 cm) diameter, 1994

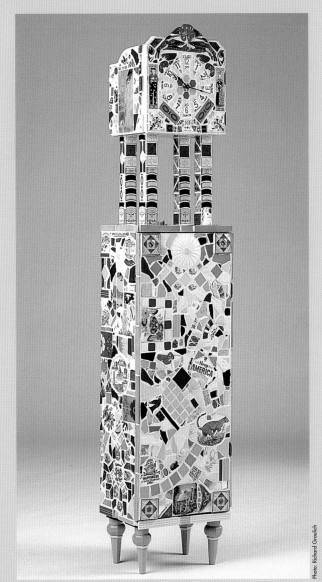

Zoe and Steve Terlizzese, *The Godfather of Time*, broken crockery and ceramic tile, 65" x 14" x 9" (165 x 35.5 x 23 cm), 1994

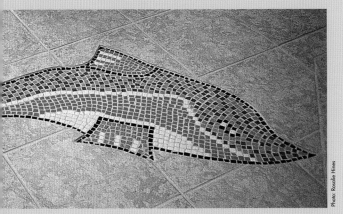

Richard Hines, one of four dolphins in the foyer of the artist's home, ceramic tile, each dolphin is 18" x 62" (.5 x 1.6 m), 1995

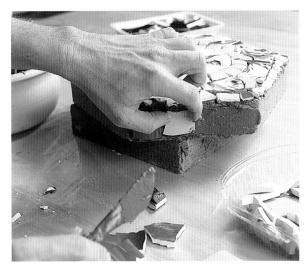

When they're applied to the vertical edges of the paver, the tesserae have a tendency to slip, so it's especially important at this stage that your mortar not be too runny. If the mortar isn't thick enough to hold the tesserae in place, don't add dry mortar to the existing mix; make a new batch instead.

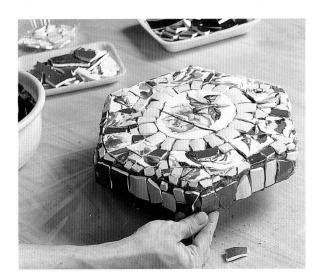

Where you install your stepping stone may influence how much attention you pay to the mosaic on the edges; if the paver will rest on the ground with the edges visible, vary the colors of your tesserae for added interest. Then, when your mosaic is finished, allow it to dry undistrubed for 24 hours.

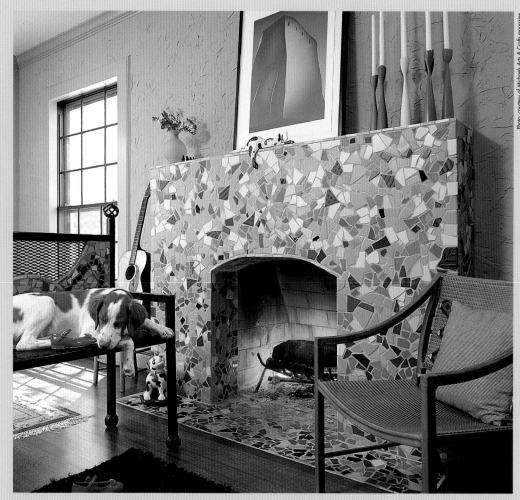

Karen Barnett, fireplace in a
private residence, broken
ceramic tile, 1993

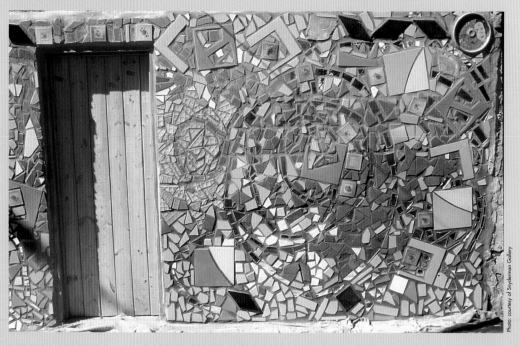

Isaiah Zagar, wall on Schell
Street in Philadelphia, ce-
ramic tile, 8' x 14' (2.4 x
4.3 m), 1993

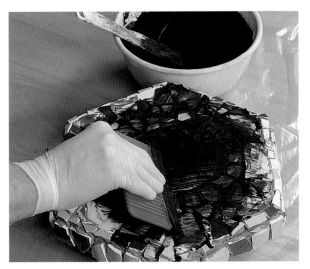

Clean off any smears or clumps of mortar from the surface of the mosaic using your fingernail or a small spatula. With your hands protected by latex or rubber gloves, mix a small batch of grout. Place about a cupful of cool water in a bowl and gradually add dry grout, mixing it with a spatula or trowel until you have a thick but smooth consistency. Apply an even coating to the surface and press the grout into the crevices with a grout spreader or hard rubber float.

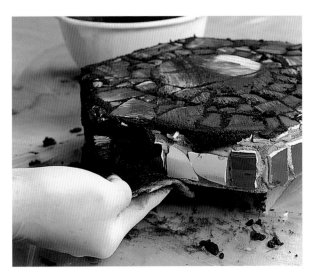

When grouting the edges of the paver, a small piece of polyethylene foam sheeting (a packing material) makes a handy tool because it's more pliable than a grout spreader or float.

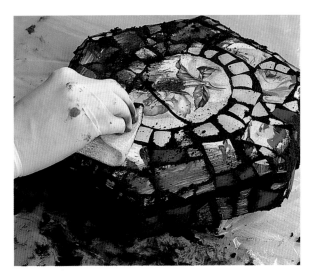

Once all the crevices are filled with grout, remove the excess by vigorously wiping the entire mosaic in a circular motion using pieces of foam sheeting or slightly damp lint-free rags. Continue wiping, frequently turning your foam sheet or rag to a clean area, to remove the haze from the surface.

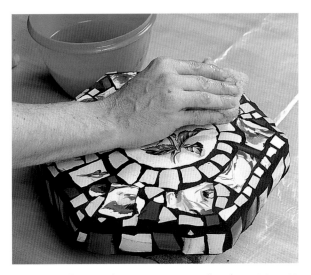

After allowing the grout to set up for about 30 to 60 minutes, wipe off any remaining haze with a barely damp sponge or clean rag. Then set the mosaic aside for at least 24 hours. Once it has fully cured, you can apply a penetrating sealer to help protect the grout from the weather if desired.

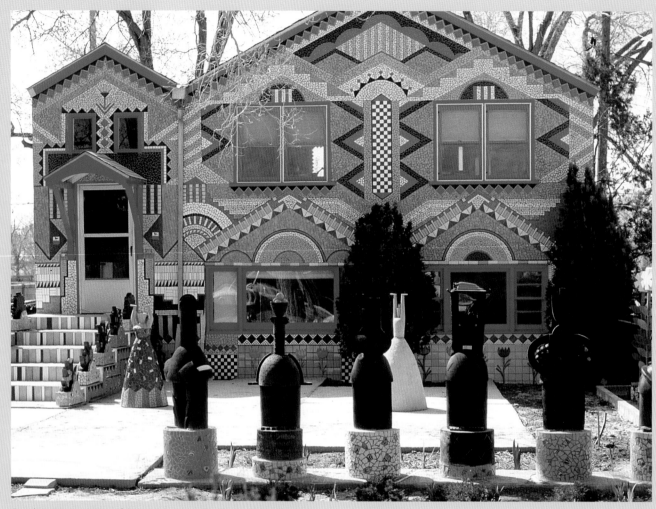

Beverly Magennis, exterior of the artist's home in Albuquerque, New Mexico, ceramic tile, begun in 1985

Laurel Neff, exterior signage at Mother Fools Coffee House in Madison, Wisconsin, ceramic tile, 1994

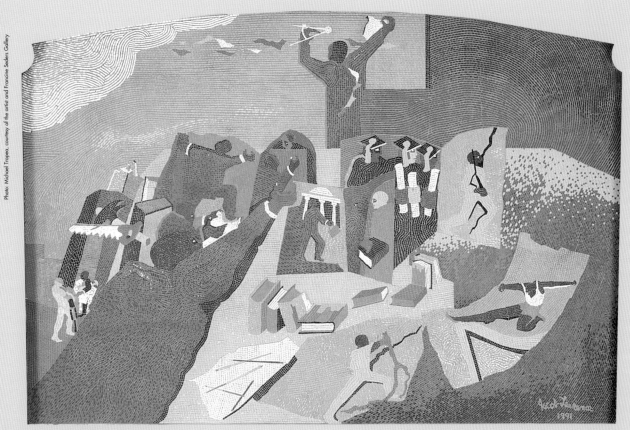

Jacob Lawrence, *Events in the Life of Harold Washington*, ceramic tile, 10½' x 15¼' (3.2 x 4.6 m), commissioned by the Chicago Public Art Program for the Harold Washington Library Center, © City of Chicago Public Art Collection, 1991, all rights reserved

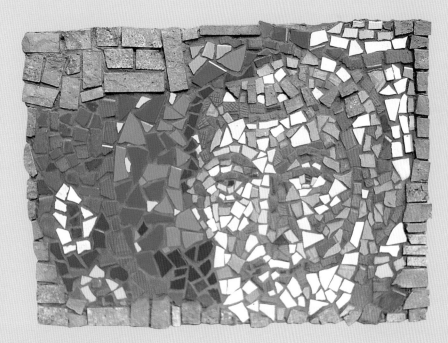

George F. Fishman, *St. Peter,*
ceramic tile and limestone, 19" x 27"
(48.5 x 68.5 cm), 1994

The Classic Direct Method

When asked to define a mosaic, most people respond by describing the direct method: tesserae are cut to size and placed face up onto a prepared surface to form a design. This approach has the advantage of immediate satisfaction—what you see is what you will get. Because you're placing each bit of stone or tile into a soft medium (mortar), the surface of your mosaic will be slightly uneven. These variations can be used to your advantage; you can place individual tesserae so they catch the light most favorably.

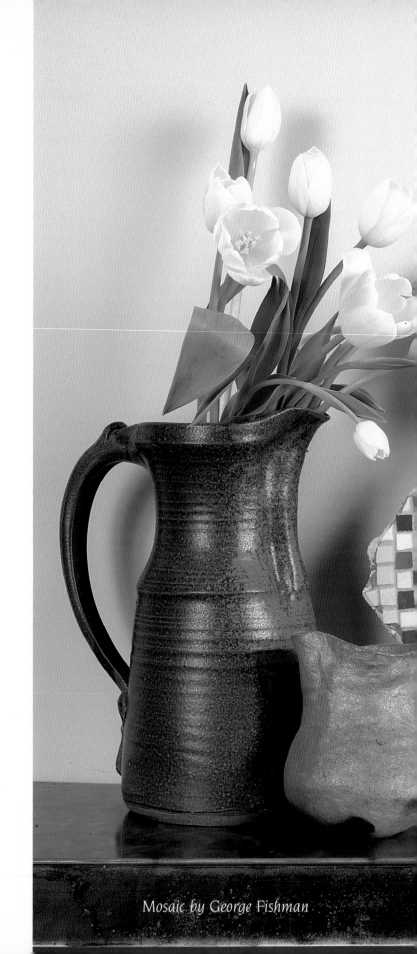

Mosaic by George Fishman

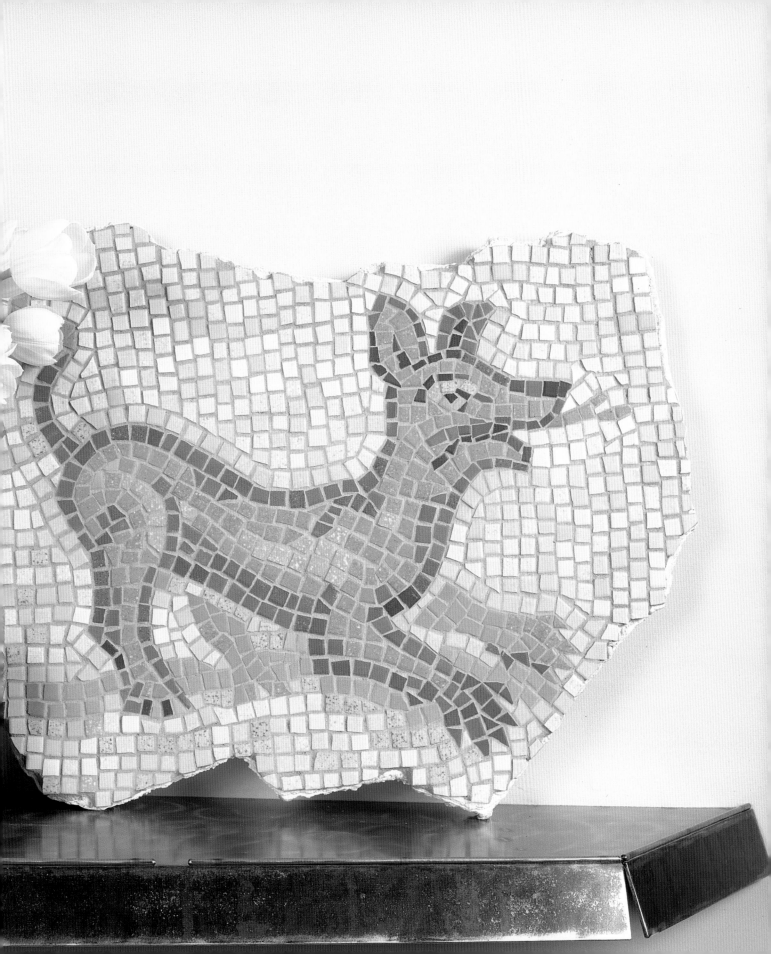

In addition to its spontaneity, the direct method offers you the opportunity to compose your design with unlike materials—a thin piece of richly colored glass right next to a protuberant fragment of textured stone. It's also the method of choice when working on a three-dimensional surface. Lest you think you'll be working completely without a net when using this approach, rest assured that you can prepare a drawing ahead of time and transfer it to your work surface before you begin the mosaic.

Begin by sketching your design onto a piece of paper. This mosaic was inspired by ancient Roman mosaic fragments and the artist's dog Rudy, who loves to play fetch. When designing your own mosaic, simplify the forms and don't include too many details. Keep in mind what is practical to achieve, based upon the sizes you intend to cut your materials.

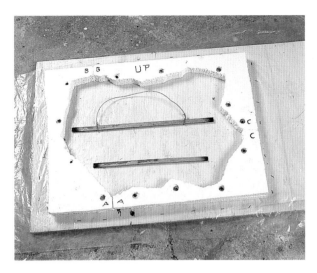

The overall shape of your mosaic should complement the design. One of the easiest ways to make an irregular "fragment" is to cast a concrete base. To make a form, cut sheets of polystyrene foam into the appropriate shapes and piece them together, securing the foam in place with screws and washers onto a plastic-covered wood board. Stretch the plastic taut to ensure a smooth working surface.

Cut two lengths of galvanized steel strapping or a piece of heavy galvanized wire mesh to reinforce the cast concrete. If desired, make a hanger by wrapping a length of wire onto one of the reinforcements.

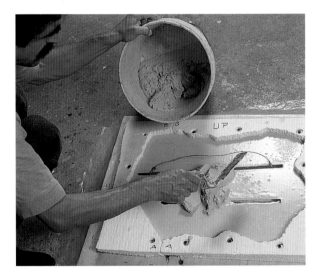

To make the concrete, mix together three parts sand and one part Portland cement (either white, as used here, or gray); then add the dry ingredients to one part water. The consistency should be that of thick mud. Pour the concrete into the form, filling it half full. After smoothing the

surface with a trowel, eliminate any air bubbles by jostling the form. Then add the steel reinforcements.

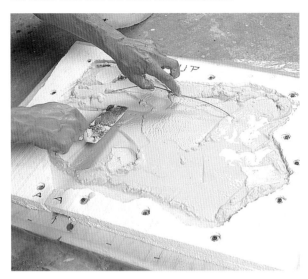

Fill the form with the remaining material and jostle it again. Holding the wire hanger out of the wet concrete, smooth the surface with a trowel. Then allow the base to dry for 24 hours.

To remove the casting, simply unscrew the foam sections from the wood board; they shouldn't stick to the concrete and can be used again for another project.

Use carbon paper and a dull pencil to transfer your mosaic design to the smooth face of the cast plaque. When the tracing is complete, go over the carbon marks with a waterproof marking pen so that your lines can be wiped with a damp sponge without smearing.

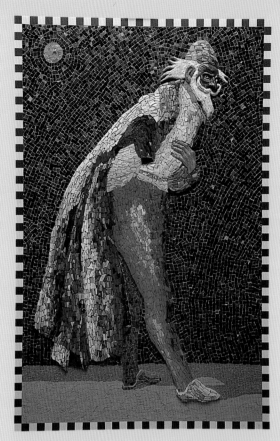

Martin Cheek, *Pantaloon (after Callot)*, glass, smalti, and mirror, 48½" x 31½" (123 x 80 cm), 1993

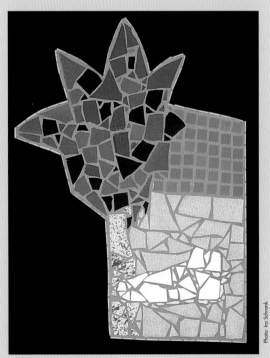

Nancy Gotthart, *Hermes at Memphis*, ceramic tile, 28" x 21" (71 x 53.5 cm), 1995

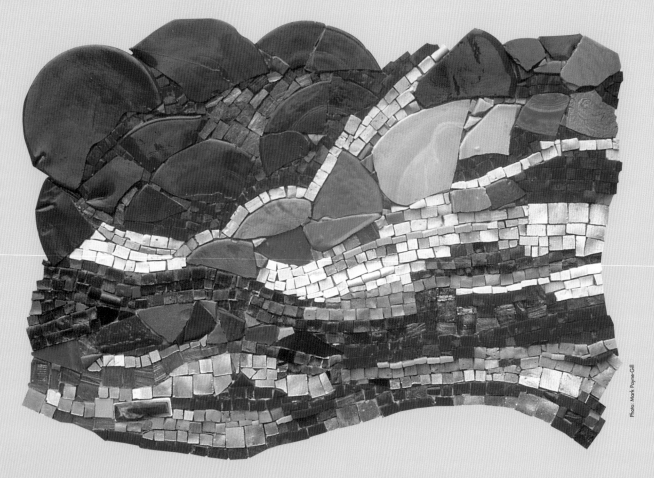

Photo: Mark Payne-Gill

Jane Muir, *Bleu d'outremer*, smalti, gold leaf, and handmade glass fusions, 22" x 29" (56 x 74 cm), 1991

Toby Mason, Untitled, reflective glass, 6½" x 22¼" (16.5 x 56.5 cm), 1996

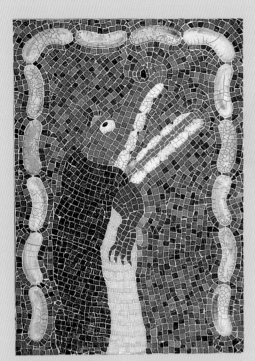

Martin Cheek, *Crocodile & Sausages*, glass and raku-fired ceramics, 24¼" x 17½" (61.5 x 44.5 cm), 1994

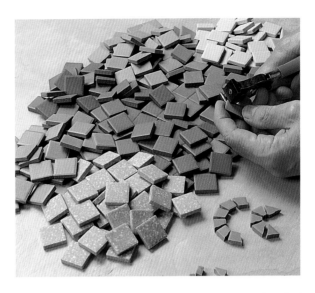

Cut a quantity of tesserae into unit sizes that feel comfortable for you. This mosaic is constructed using 2" (5 cm) unglazed porcelain tiles that have been cut into quarters. For added convenience as you work, sort the tesserae by color.

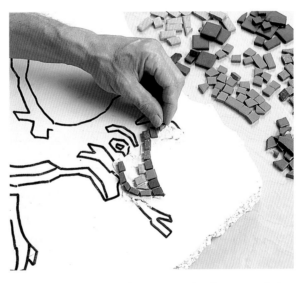

Using a commercial mix or starting from scratch (see page 22), mix a batch of cement mortar. (If you used white cement for your plaque, you may want to make white mortar to match.) Make only as much as you can use in a couple of hours. While the mortar cures for about 15 minutes, wipe the plaque with a wet sponge to prevent it from drawing too much moisture from the mortar.

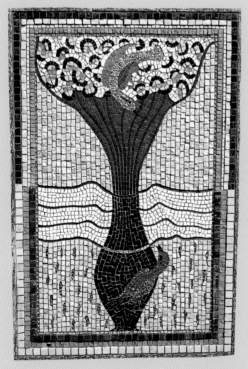

Elaine M. Goodwin, *To Know No Boundaries*, gold smalti, smalti, marble, and iron pyrites, 43¼" x 29" (110 x 74 cm), 1994

Apply a thin coating of mortar to a small area of the plaque and begin outlining your subject, lightly buttering the backs of the tesserae before placing them. Starting with the outline establishes the contours of your subject and allows you to vary the sizes of tesserae used within the contours to fit. If you start inside and work outward, you may run short of space and have to make do with a thin, less well-defined contour.

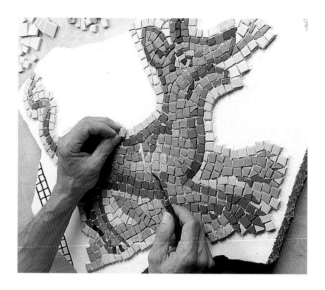

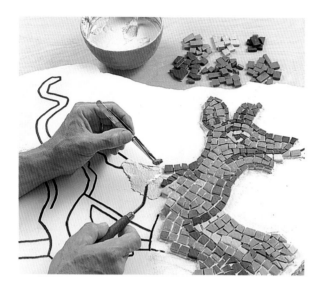

Begin filling in the area just outlined, leaving small gaps between tesserae for the grout. When placing tesserae, choose a range of shades within color families to create shadow effects and add depth to your composition. If you want your mosaic to have a flatter, more uniform surface, gently beat each area as it's just completed, using a block of wood or a dry grout float.

Although every artist has a different style, classic mosaics often have a "halo" of background color that follows the contour of the subject to create a smooth transition between the central motif and the background. The halo may include one, two, or even three layers, depending upon the design.

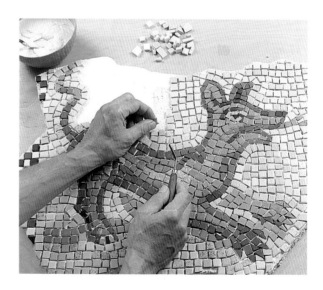

With the halo complete, begin filling in the background. Here it's done in *opus tessellatum*, a rectilinear arrangement of the pieces. In ancient mosaics, *opus tessellatum* doesn't always consist of a single perfect grid. Some portions are angled slightly to "follow" the subject, and the grids blend where they meet. Complete the background as desired; then allow the mosaic to dry for 24 hours.

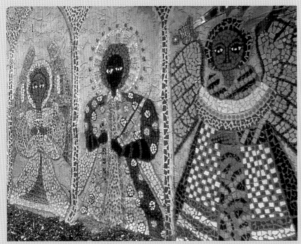

Lily Yeh and James Maxton, *Angel Alley*, a wall mural in Philadelphia, 1991

Lily Yeh painting the "cartoon" for *Angel Alley*

James Maxton working on *Tree of Life*

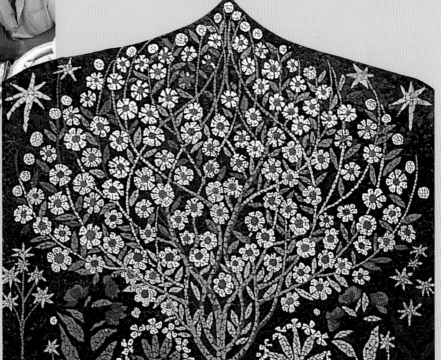

Lily Yeh and James Maxton, *Tree of Life*, wall mural
in Meditation Park, Philadelphia, ceramic tile, 1994

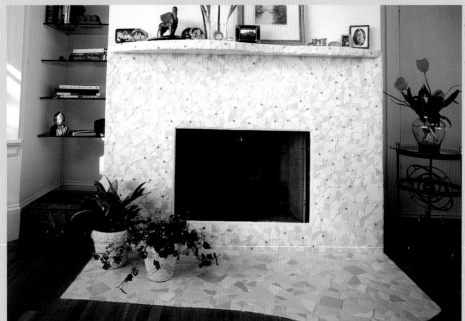

Photo: Joyce Oudkerk Pool

Karen Thompson, bedroom fireplace in a private residence, glass and ceramic tile, 1990

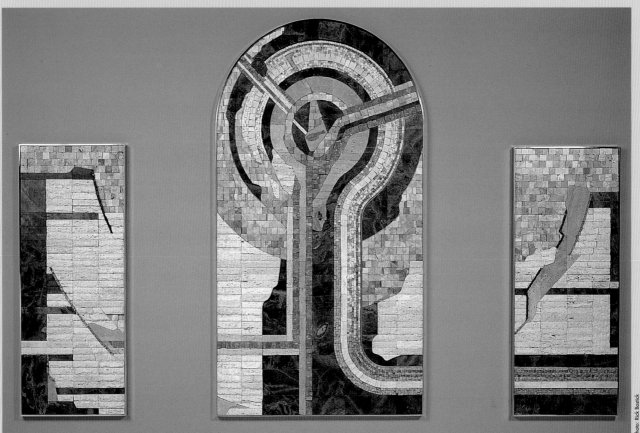

Photo: Rick Bostick

Jim Piercey, *AIA Triptych*, marble, travertine, slate, fieldstone, brass, and fossils, 66" x 109" (1.7 x 2.8 m), 1987

Marcia and John Koverman, *Untitled*, ceramic tile, 20" x 14" (51 x 35.5 cm), 1994

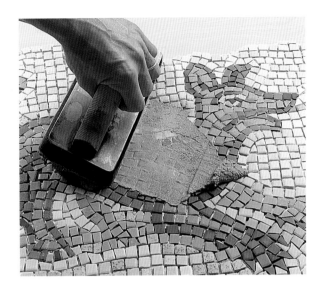

Mix a small batch of dry grout, starting with about a cupful of cool water. Stirring continuously, add the dry powder until you have a thick, smooth consistency. Apply the grout to the mosaic, using a hard rubber float to press it into the crevices. Around the perimeter of the mosaic, work the grout inward from the edges toward the center. The rough edges of the cast plaque need no finish unless one is desired.

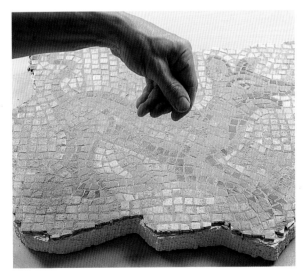

Sprinkle some dry grout powder on the surface of the mosaic. This helps brighten the color of the grout and accelerates its drying time. If you notice some exposed edges of tile around the outside of the mosaic, don't be concerned. You needn't have grout everywhere to hold each piece in place; there should be sufficient bond from below and from the other sides.

Chris Carbonell, *Untitled*, white glass and black cement, 13" x 9" (33 x 23 cm), 1995

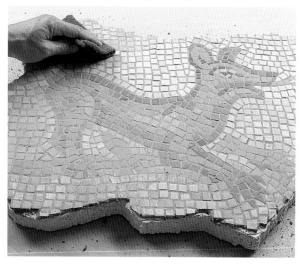

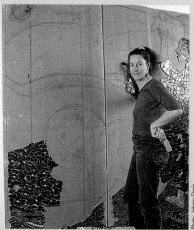

Elizabeth Raybee in her studio, creating *Night Sky Women* on a series of cement panels, later installed on site, 1992

After waiting for the grout to set up for about 10 or 15 minutes, wipe the surface with a damp nylon scouring pad. Rinse the pad frequently and use as little moisture as possible on the mosaic to avoid weakening the grout. Don't concentrate on one area, or the grout will skin over in others. Work the entire mosaic, going back over areas to remove successive layers of excess grout and moving in various directions to keep from dragging too much grout from some channels. Complete the cleaning with a dry rag, frequently turning the rag to a clean area.

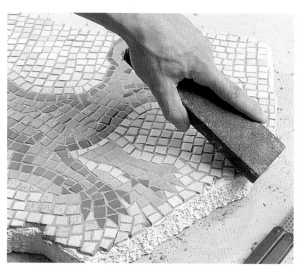

Allow the grout to dry for 24 hours; then smooth any sharp corners with a tile stone, an abrasive stone similar to a knife sharpening stone, or use a diamond file.

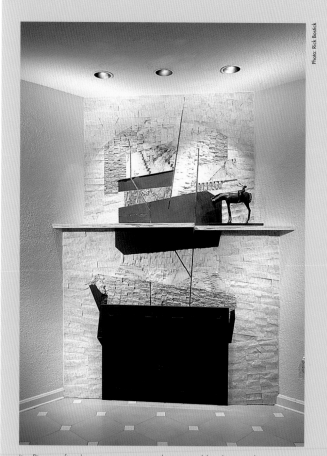

Jim Piercey, fireplace in a private residence, marble, slate, and gold smalti, 7'10" x 6' (2.4 x 1.8 m), 1989

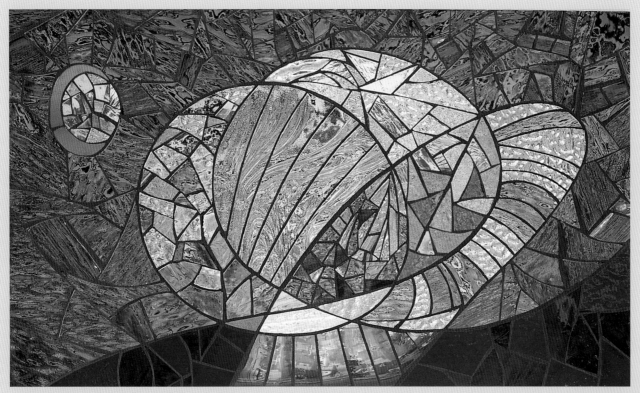

Toby Mason, *Before the Wind*, reflective glass, 15" x 25¼" (38 x 64 cm), 1995

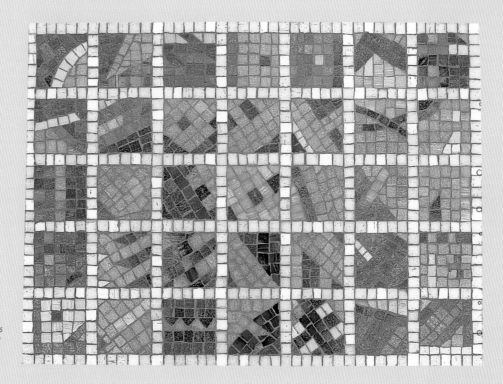

Susan Goldblatt, *Mosaic Matters
No. 4*, vitreous glass, 12" x 17"
(30.5 x 43 cm), 1995

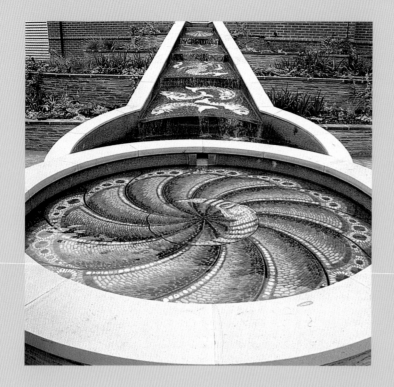

Left: Maggy Howarth, water cascade at East Cleveland Hospital in Cleveland, England, pebbles, cascade is 30' (9 m) long, 1995

Above: Detail of mermaid mosaic in water cascade

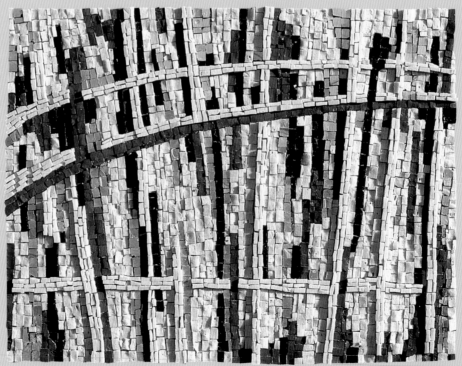

Jane Muir, *Intervals*, smalti and gold leaf, 19" x 25¼" (48 x 64 cm), 1988

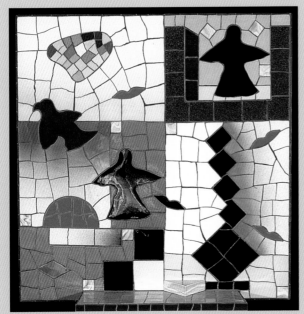

Joseph DiStefano, *Smith's Gift*, handmade ceramic tile, 39" x 39" (99 x 99 cm), 1978

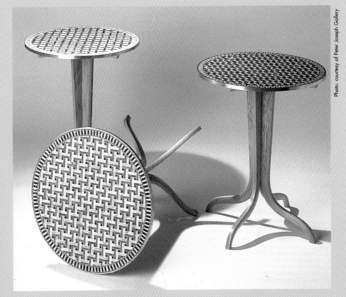

Michael Hurwitz, café tables, marble, 24" (61 cm) and 30" (76 cm) diameter, 1994

Ruth O'Day, *Communication*, inlay-style mosaic of hand-cut and carved clay tiles, 27" x 36" (68.5 x 91.5 cm), 1994

THE INDIRECT METHOD

For those of us who want to be sure of ourselves before committing to anything permanent, the indirect method is a godsend. This technique allows you to create—and recreate—your design on a temporary surface before cementing it in place. As a result, you can construct your entire mosaic off site, then install it whenever convenient. The finished product has a much flatter, more uniform surface than one created using the direct method. This is advantageous for a floor mosaic, where an irregular surface may be undesirable.

Mosaic by George Fishman

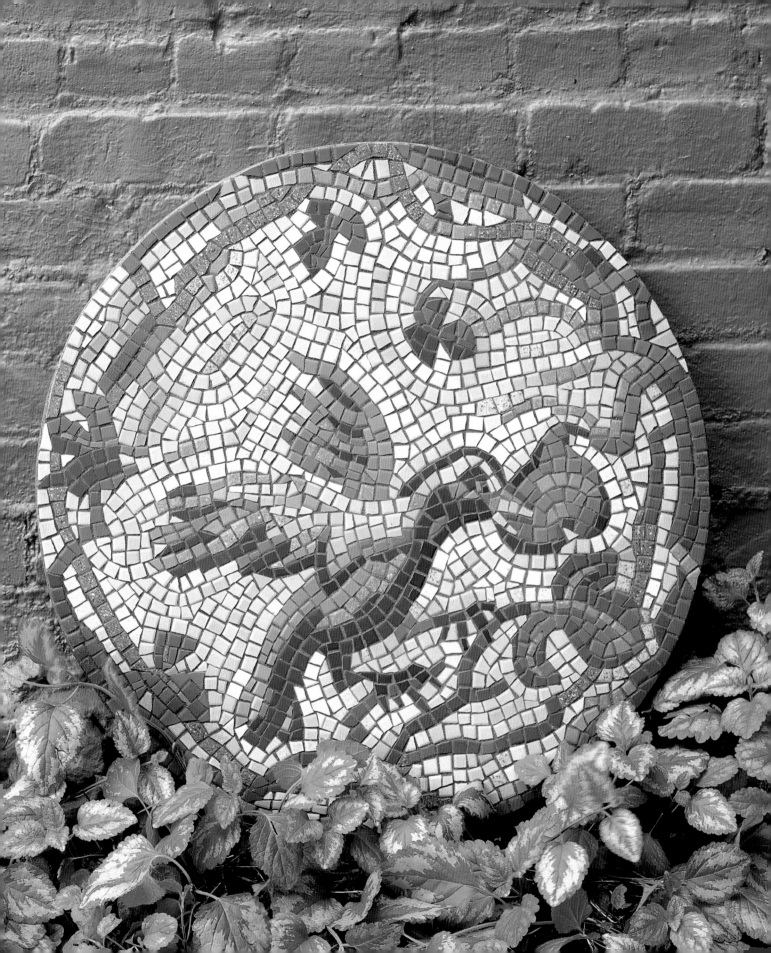

In the classic indirect method, the tesserae are glued face down onto brown kraft paper using a water-soluble adhesive. Then the back (visible surface) of the mosaic is cemented onto its permanent support and the paper peeled away, revealing a design that's a mirror image of the working mosaic. The procedure described here uses two types of clear adhesive film in place of paper and glue, which allows you to see the finished surface as you work and maintain the same orientation of your design throughout the process.

Secure the drawing to your work surface with a piece of tape at each corner. Then cut sufficient paper-backed clear adhesive film to cover your drawing. (This material is commonly sold in hardware stores to line drawers and shelves.) You may need to piece two or more sections together if your mosaic is large. With the sticky side facing *up*, tape the corners of the film to your work surface to hold it in place over the drawing.

Sketch your design full size onto a piece of paper. Drawings done in color give you a better approximation of the ultimate design, but they may constrain your creativity during the mosaic process. A black-and-white sketch provides less information but more freedom.

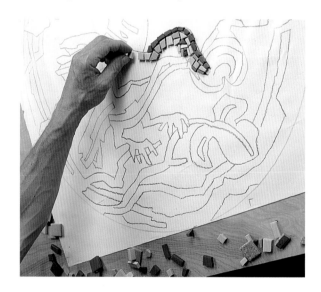

Cut a quantity of tesserae in the range of colors you plan to use. Then begin outlining an area of your subject, making sure to leave gaps for the grout. If you change your mind about placement or color, feel free to move or exchange the tesserae.

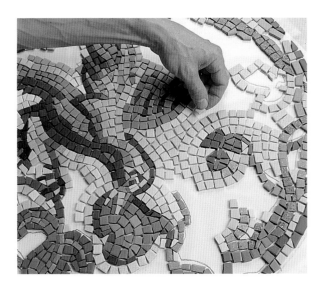

Fill in the subject of your design, using the *adamento* or flow of the tesserae to emphasize the forms. Variations in color help create shadow effects and imply mass.

After completing the subject, begin applying the background tesserae. Here the first row of background color follows the contours of each motif in a curvilinear "halo." This style is called *opus vermiculatum*, and it provides a smooth transition from the subject to the background.

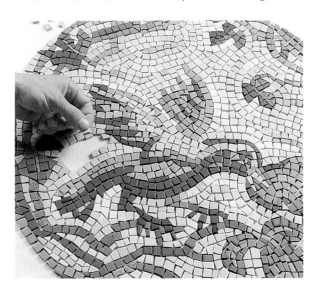

In this mosaic, each successive row of background tesserae echoes the contours of the row before it. Continuing the curves in the *opus vermiculatum* style not only emphasizes the movement and form of the subjects, but it also melds nicely with the circular shape of the mosaic.

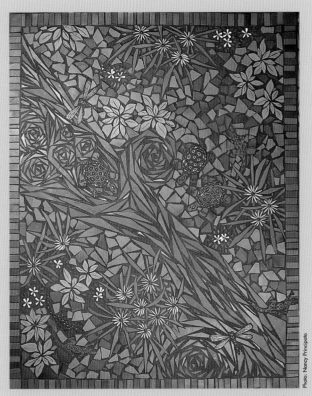

Photo: Nancy Principato

Will Mead, *Woodland Mosaic*, floor insert at the artist's residence, hand-made and cut ceramic tile, 4' x 5' (1.2 x 1.5 m), 1995

Photo: Nancy Principato

Detail of *Woodland Mosaic*

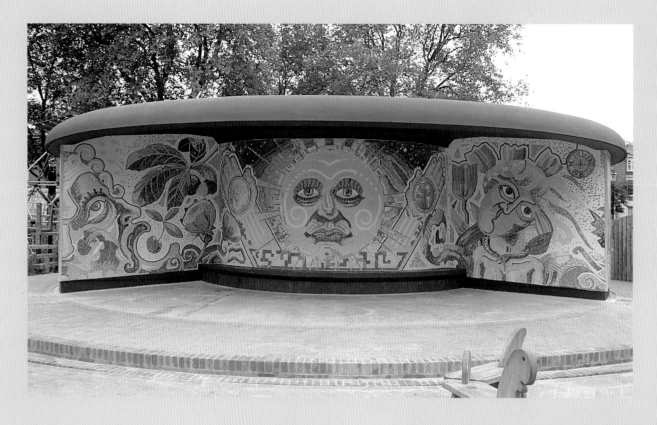

Above: Magnus Irvin, *Four Seasons*, rest area at Highbury Fields in London, vitreous glass, 8' x 120' (2.4 x 36.6 m), 1987

Below: *Four Seasons* partially underway in the artist's studio

Below right: Detail of *Four Seasons*

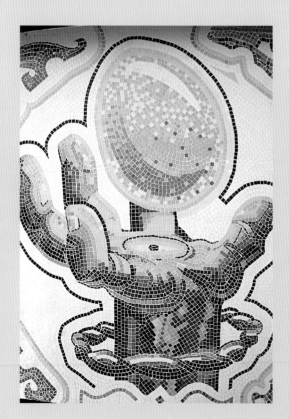

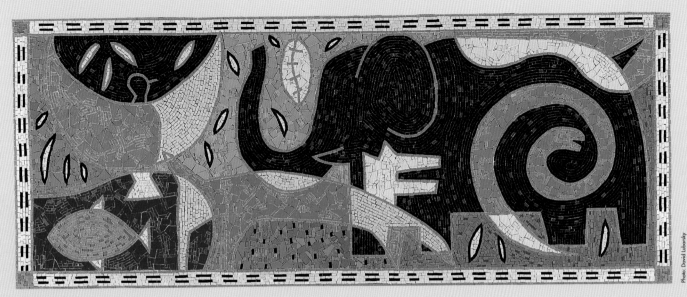

Peter Columbo and Jose Ortega, *Untitled*, wall mural at the 149th Street station of the #2 and #5 subways in Bronx, New York, handmade ceramic tile, 4' x 8' (1.2 x 2.4 m), 1996

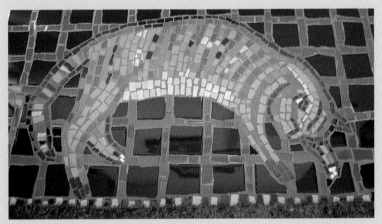

Joanna Dewfall, *Gabby*, fireplace hearth in a private residence, glazed ceramic tile, 16" x 40" (40.5 x 101.5 cm), 1995

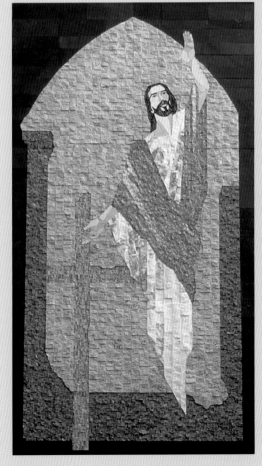

Jim Piercey, *Untitled*, St. Stephen Catholic Church in Winter Springs, Florida, 10' x 5' (3 x 1.5 m), 1991

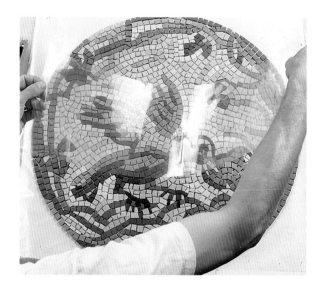

When your design is complete, gently but decisively place high-tack clear adhesive film sticky side *down* onto your mosaic. (This material is an industrial tape product that has stronger adhesive properties than the film used to assemble the mosaic. If high-tack film isn't available in your area, substitute kraft paper coated with a thin layer of wallpaper paste.) Overlap two or more strips of film if necessary to get complete coverage.

After placing the film, rub the surface with a clean cloth to adhere all the tesserae. Then use a sharp blade to trim the film to the edges of the mosaic, taking care not to cut through the bottom layer of film. This will allow you to apply mortar to the outer edges of the mosaic .

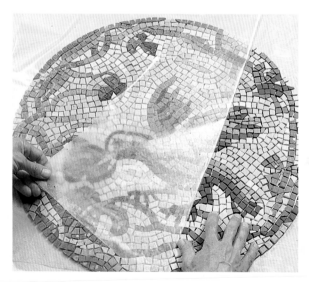

Temporarily place the mosaic between two sheets of plywood and flip it over. Then gently peel off the low-tack film from the mosaic. To minimize dislodging the tesserae, use as low an angle as possible when removing the film.

Cut a scrap piece of the high-tack film (or kraft paper and wallpaper paste) and apply a handful of tesserae to it to use as a test sample. A test sample will allow you to check how thoroughly the mortar has set without disturbing your mosaic.

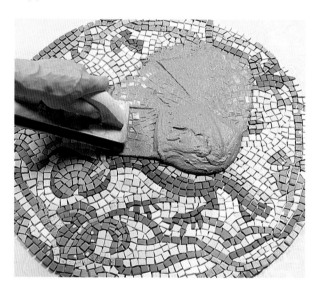

Mix a batch of cement mortar according to the manufacturer's instructions, making enough to cover the mosaic and the cement backing board. (If you're using a plywood backer, substitute a latex-based commercial tile adhesive for the mortar.) While the mortar cures for 10 or 15 minutes, cut the backing board into a square somewhat larger than your mosaic. Cut a scrap piece of board for your test sample. For a cement backer, use a circular saw with a masonry blade to make the cuts.

Scrape the mortar across the surface of the mosaic with a hard rubber grout float, holding the tool at an angle of about 30° and using moderate pressure. Cover the mosaic (and test sample) with a thin coat and drive some mortar into the crevices. Don't lift the float straight up, or you may dislodge some tesserae. If some do come loose, don't try to put them back; clean and set them aside to replace later.

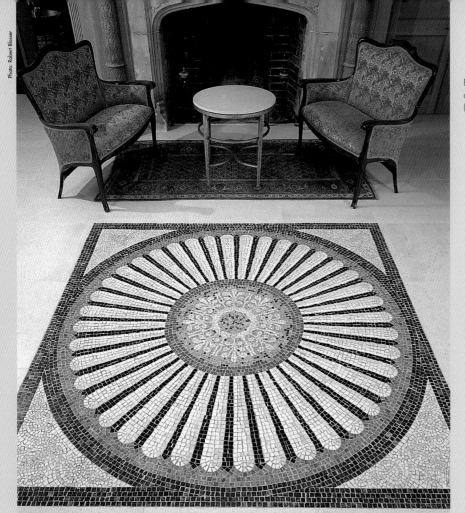

Peter Columbo, floor medallion in a private residence in Bridgehampton, New York, marble, 7' (2.1 m) diameter, 1994

Jeni Stewart-Smith, *Untitled*, vitreous glass, ceramic tile, stained glass, and smalti, 18" x 8" (45.5 x 20.5 cm), 1995

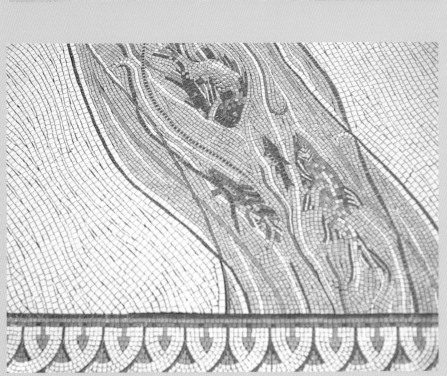

Marcia and John Koverman, section of a mosaic floor in a private residence, ceramic tile, 1995

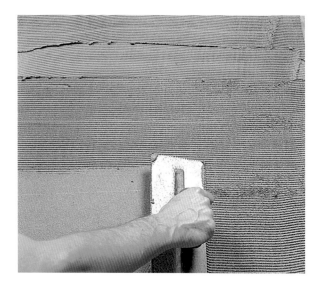

Using the smooth portion of a notched trowel, spread an even coating of mortar across the surface of the backing panel, applying sufficient force to press the mortar onto the surface. Then make even passes with the notched side of the trowel. The size of the notches sets the depth of the mortar applied; if you have tesserae of various thicknesses, you must apply enough mortar so that the thicker ones don't touch the board before the thinner ones rest on mortar.

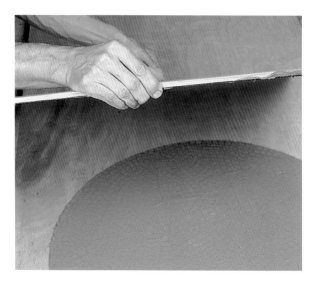

Set the panel onto the mosaic, coming down flat and evenly. Try to center the panel as best you can, but don't peel it loose if it's a bit off center. (You'll trim the backing board to exact size later.) Then beat the surface of the board with your hands to bond it to the mosaic. Repeat the process with the test sample.

Twyla Arthur, courtyard at the University of California at Berkeley, concrete tile, 1' x 70' (.3 x 21.3 m), 1995

Carlos Alves, *Atlantis*, ceramic tile, South Florida Art Center in Miami Beach, 1988

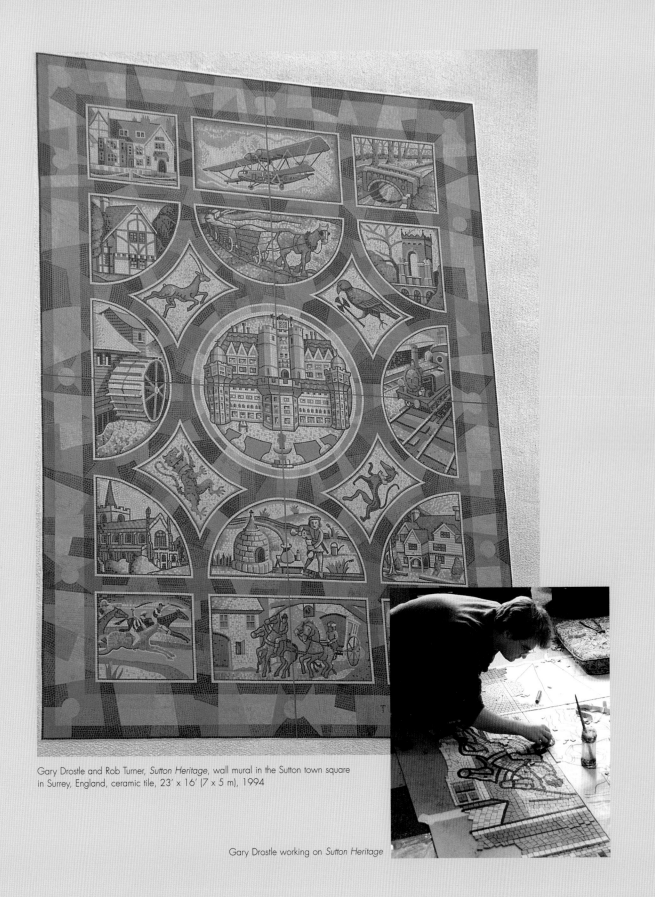

Gary Drostle and Rob Turner, *Sutton Heritage*, wall mural in the Sutton town square in Surrey, England, ceramic tile, 23' x 16' (7 x 5 m), 1994

Gary Drostle working on *Sutton Heritage*

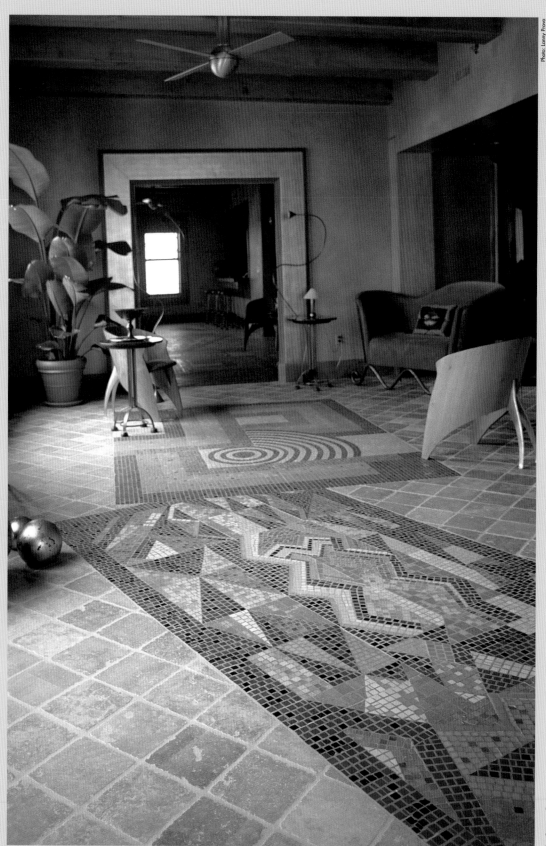

George F. Fishman, *Deco Rugs*, vitreous glass and ceramic tile, each rug is 6′ x 8′ (1.8 x 2.4 m), 1993

Elizabeth Raybee, Splash, ceramic tile, 26" x 36" (66 x 91.5 cm), 1995

Placing a board under the mosaic to secure it, turn over the whole assembly. Brush off any globs of mortar; then beat the film-covered mosaic with a hard rubber grout float, coming straight down onto the surface with the float. This further bonds the mosaic to the mortar.

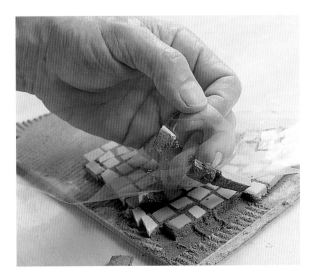

Wait at least 16 hours to test the sample. (Shown here is the result of removing the film prematurely.) Then peel off the film gently and evenly, without jerking it. Pull at a low angle to avoid dislodging any tesserae. Cement mortar can take up to a month to cure completely, but it sets sufficiently to proceed after 16 to 24 hours.

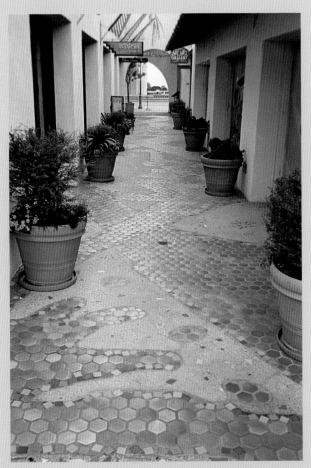

Alison Cooper, walkway at the Del Mar Plaza in Del Mar, California, ceramic tile and concrete, 13' x 80' (4 x 24.4 m), 1988

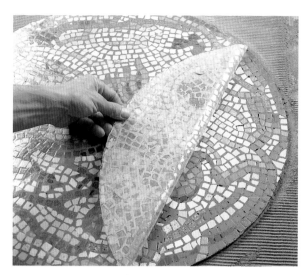

Once you're confident the mortar has set, remove the film from the mosaic. Again, pull smoothly and hold the film at a low angle as you peel it off.

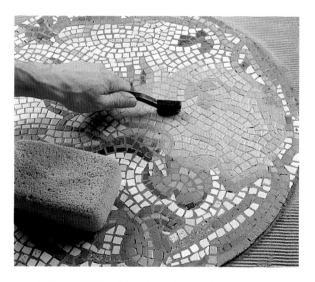

Using a stiff toothbrush and a small amount of water, vigorously brush the surface of the mosaic to loosen excess mortar that may have covered portions of the tesserae. Work the brush evenly across the surface of the mosaic to accentuate the grout lines; then remove the excess mortar with a damp sponge.

Mix a small batch of grout, starting with about a cupful of water and adding enough dry powder to obtain a thick, smooth consistency. Apply the grout to the mosaic with a hard rubber float or grout spreader. After allowing the grout to set up for about 10 minutes, wipe off the excess with a damp abrasive sponge or nylon scouring pad—not steel wool, which may scratch glazed tile and

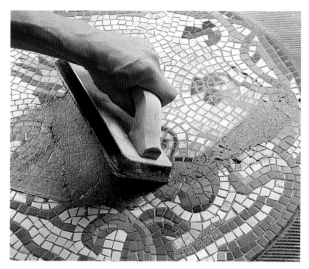

become embedded in the grout to rust later. Work the entire mosaic evenly, using circular motions and as little moisture as possible. For the final cleaning, use a dry lint-free rag, frequently turning the rag to a clean area.

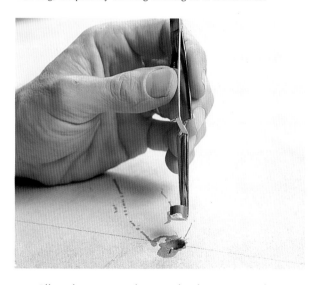

Allow the grout to dry completely, waiting at least 24 hours. Then use a jigsaw with a carbide blade to cut the cement backing board to fit the mosaic exactly. Finish the cut edges of the board with a small amount of grout.

To install hangers on the back, cut two pieces of ½" (1.5 cm) brass or stainless steel tubing into lengths equal to the thickness of the cement backing board. Use a ½" (1.5 cm) masonry bit to drill two holes evenly spaced, a little less than halfway down from the top of the mosaic. Cap off the bottom end of each tube with a small piece of tape (so the tube doesn't fill with adhesive); then glue the tubing into the holes with two-part epoxy.

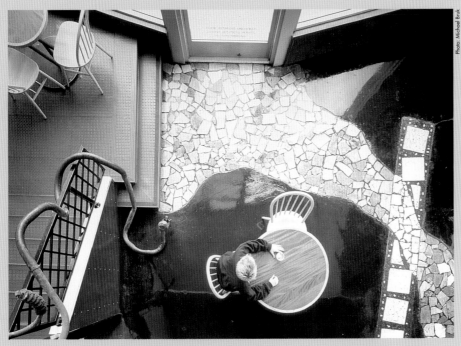

Photo: Michael Bruk

Left: Twyla Arthur, floor mosaic at the Bison Brewing Company, Berkeley, California, handmade concrete tile, 1989

Below: Detail of Bison Brewing Company floor

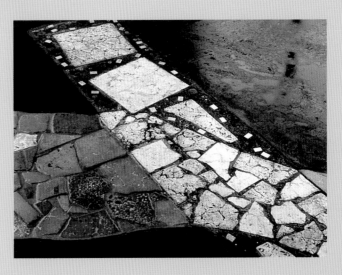

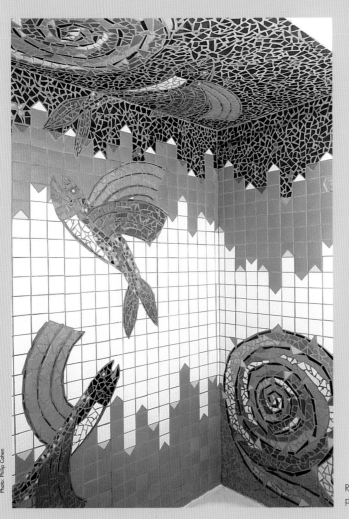

Photo: Philip Cohen

Right: Elizabeth Raybee, *Flying Fish and Spirals*, bathroom in a private residence in Berkeley, California, ceramic tile, 1992

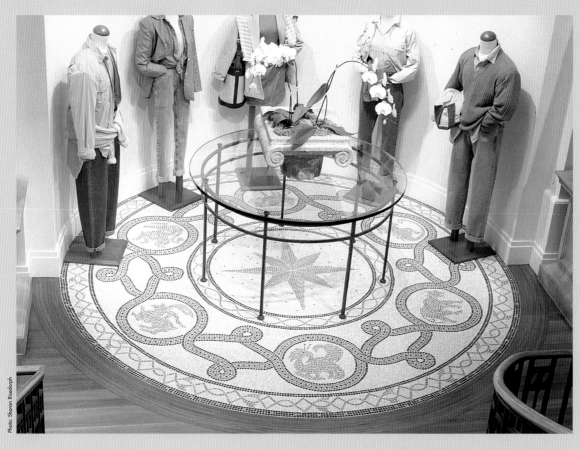

Karen Thompson, floor
medallion at the Banana
Republic in Beverly Hills,
California, marble and pebbles,
11' (3.4 m) diameter, 1992

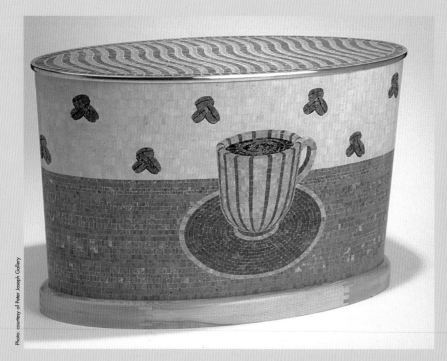

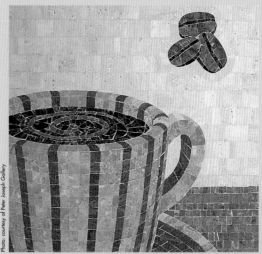

Left: Michael Hurwitz, *Espresso Bar*, marble, 36" x 60" x 31"
(.9 x 1.5 x .8 m), 1994

Above: Detail of *Espresso Bar*

Making Mosaics

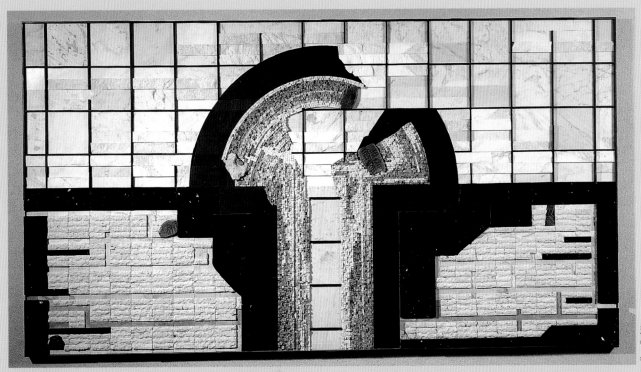

Jim Piercey, *Maze II*, wall mural at the Florida School for the Deaf and Blind in St. Augustine, marble, travertine, slate, and fossils, 5' x 9' (1.5 x 2.7 m), 1989

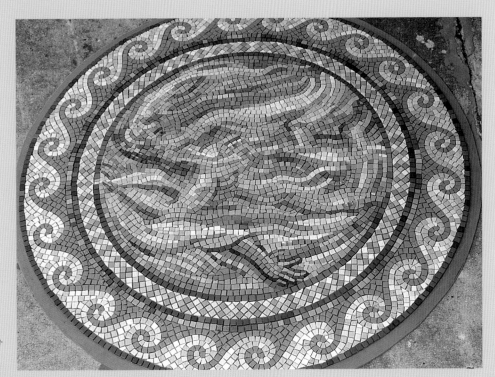

George F. Fishman, *Swimmer*, floor medallion before installation and grouting, installed on the deck of a cruise ship, 42" (106.5 cm) diameter, 1994

The Indirect Method

SCULPTURAL FORMS

*Working in three dimensions
offers unique challenges to a
mosaicist. Unlike flat designs,
sculptural mosaics may be viewed
from many angles, so you should give
equal attention to every surface. Your
style of working may be impacted as
well; due to the contours of your base,
you may need to cut smaller tesserae
than you would ordinarily. Most
important of all, you must keep your
design from succumbing to the forces
of gravity as you assemble it.*

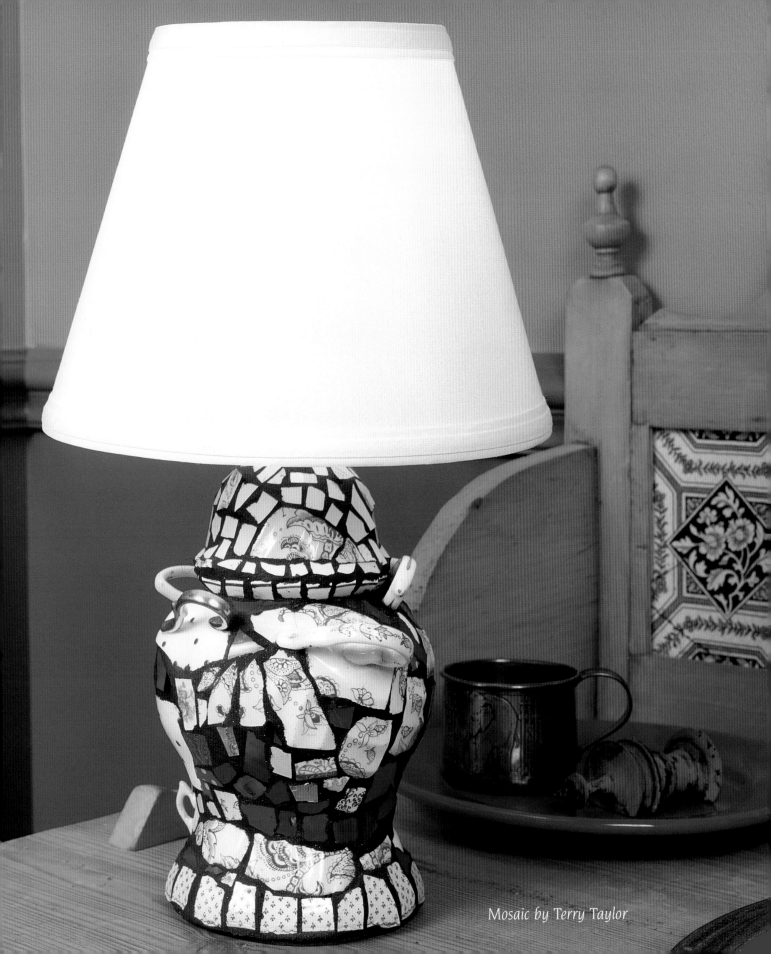

Mosaic by Terry Taylor

Three-dimensional objects such as umbrella stands, urns, spice racks, and porch columns can be covered with any type of mosaic—a classic geometric pattern, formal still life, or abstract design. The example shown here is done in pique assiette, which provides an ideal opportunity to incorporate some unconventional elements into the mosaic. The only constraint when making a sculptural mosaic is that it's best accomplished using the direct method.

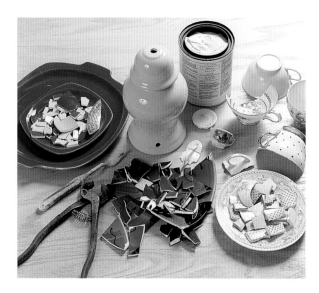

Choose an object to cover in mosaic. If this is your first sculptural project, you may want to opt for something not overly ambitious, such as a small porcelain lamp base. Then select an assortment of materials and cut a quantity of tesserae. Sketch your design or pattern lines directly onto the object, or plan to let the materials take you where they may.

Choosing an appropriate adhesive is especially important with a sculptural mosaic (see pages 22 and 25 for recommendations). A latex-based tile adhesive is used here because it adheres well to the glazed surface of the lamp base.

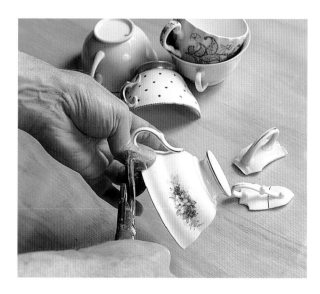

To incorporate something such as a cup handle into your design, you must first cut it into a usable piece. Don't be discouraged if your first few attempts aren't successful. This operation isn't always predictable, and it requires some patience. Make the first cut by placing your thumb next to the handle and the tile nippers next to your thumb.

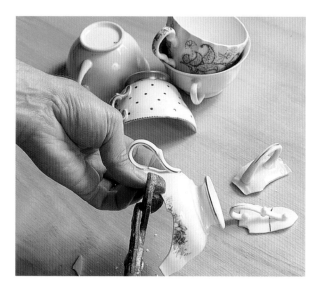

Make small additional cuts *away* from the handle. If you place the nippers too close to the handle, the resulting cut will almost certainly cause it to break. The object is to remove most of the cup and leave a small base for the handle to be attached to the mosaic.

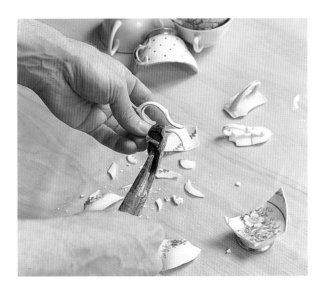

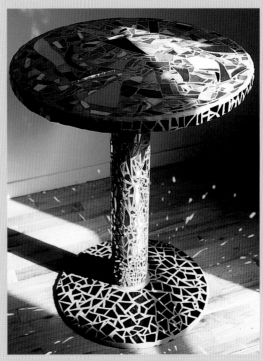

If desired, nibble away the remaining unwanted portions of the cup with very small cuts. Don't attempt to make it look perfect, however; if you're too ambitious in your cutting, you may lose the handle.

Chris Carbonell, café table, glass, mirror, and black ceramic tile, 30" (76 cm) diameter, 1987

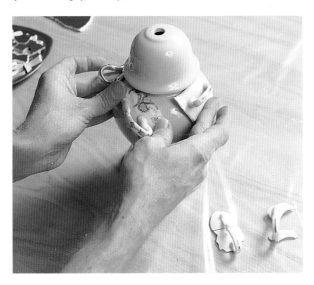

Hold the cup handles against the lamp base to determine their best placement. On this project, the natural shape of a cup works well against the broad curve of the upper part of the lamp. You can attach objects that bend against the curve of your base, but they require more adhesive and more grout to meld them into the overall form.

Roberta Kasserman, *Nesting Instinct*, ceramic tile, 28" x 9" x 11" (71 x 23 x 28 cm), 1994

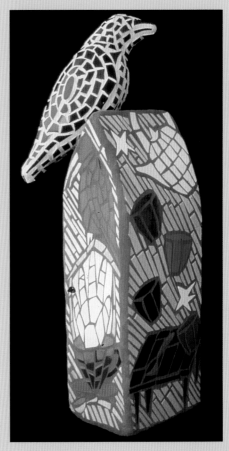

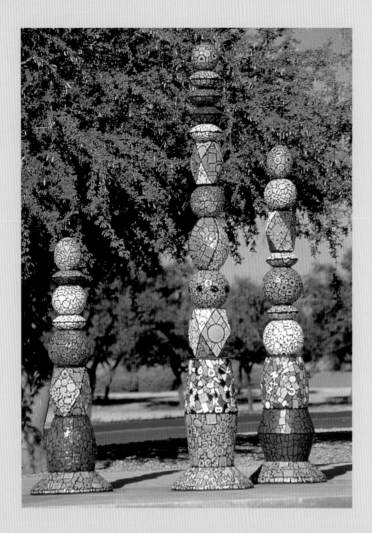

Above: Gary Bloom, *Bardrock Boogie*, clay and cut tile, 17" x 12" (43 x 30.5 cm), 1994

Left: Ron Gasowski, *Three Columns of Wisdom*, Chandler/Gilbert Community College in Chandler, Arizona, includes handmade ceramics by Chandler elementary school children, 5', 7', and 9' (1.5, 2.1, and 2.7 m) tall, 1993

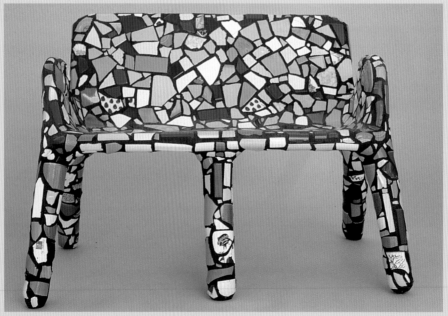

Ron Gasowski, *Love Seat*, ceramic tile over steel and concrete, 30" x 48" x 20" (76 x 122 x 51 cm), 1987

Ellen Driscoll and Peter Columbo, *Untitled*, smalti with granite frame,
14" x 14" (35.5 x 35.5 cm), 1994

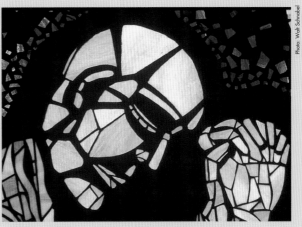

Kathryn Schnabel, center panel of *It's Not Thin Air*, stained glass and
grout, entire nine-panel piece is 6' x 6' (1.8 x 1.8 m), 1996

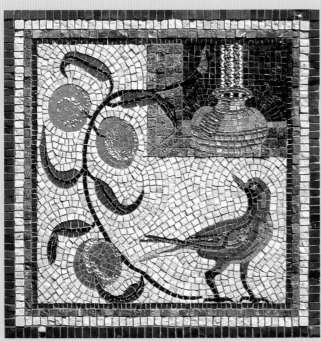

Elaine M. Goodwin, *Bird and Three Apples*, marble, white and yellow gold,
smalti, and mirror, 26" x 26" (66 x 66 cm), 1995

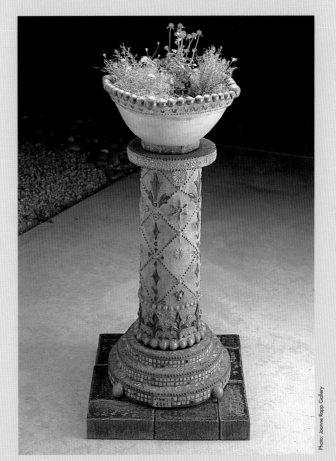

Gloria Kosco and Mimi Strang, *Relative Degree of Plentifulness*, ceramic and
masonry, 42" x 16" x 16" (106.5 x 40.5 x 40.5 cm), 1993

Debby Hagar, *Little Things Mean a Lot*, handmade glazed and unglazed terra-cotta tile, 8'8" x 7'8" (2.6 x 2.3 m), 1994

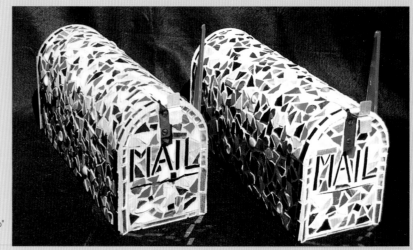

Laurel Neff, mailboxes, glass and mirror, 9" x 6½" x 16" (23 x 16.5 x 40.5 cm), 1995

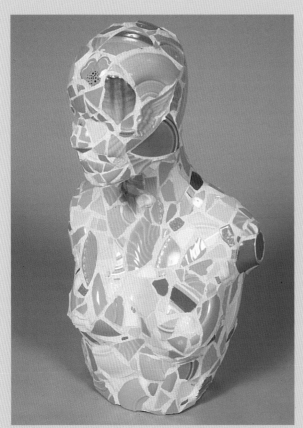

Ron Gasowski, *Miami*, found and handmade ceramic materials, 32" x 18" x 12" (81.5 x 45.5 x 30.5 cm), 1987

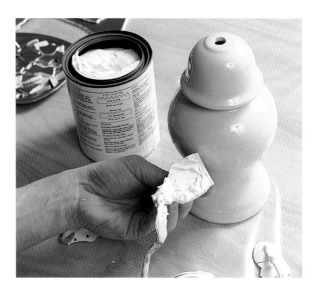

Using a palette knife or small metal spatula, apply a liberal amount of tile adhesive to the back of each cup handle. Fill the entire curve with adhesive to make sure there are no air pockets, which might cause the handle to loosen.

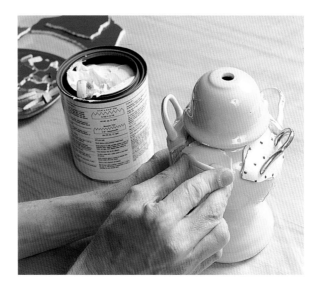

Press each handle onto the surface of the base until some of the adhesive oozes out around the edges. Then use a palette knife to scrape away any excess.

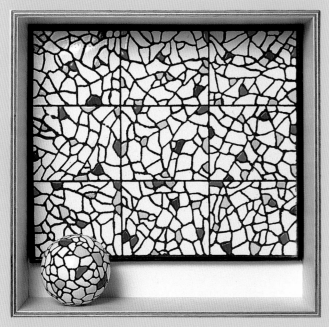

Gifford Myers, *Little Piet (le monde rien)*, glazed ceramic tile, 9½" x 9⅞" x 3¼" (24 x 25 x 8.5 cm), 1992

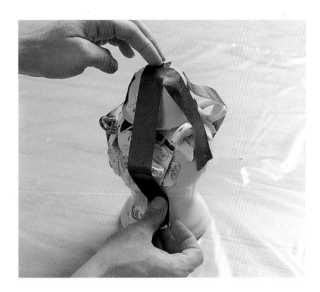

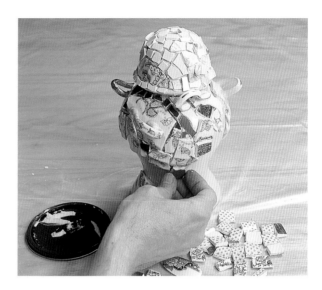

Once the cup handles are fixed in place, you may find that their weight causes them to slip out of position. Secure them in place with low-tack masking tape or similar means; then set aside your mosaic for 24 hours.

When cutting the tesserae for a rounded surface, make them small or use curved pieces from bowls, cups, or the rims of plates. Experiment with their placement; you may have to set individual tesserae where they fit best, rather than exactly where you want them. In general, sharper curves require smaller pieces.

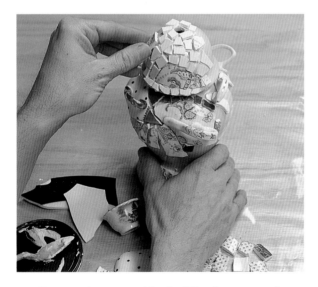

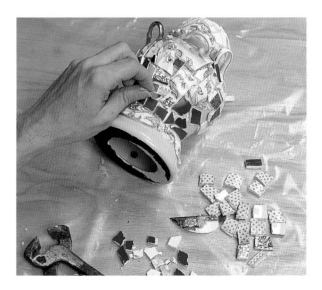

Remove the tape and begin filling in an area of your design. Liberally butter the back of each piece with adhesive before placing it, and leave small gaps for the grout.

When you're working on the top of the lamp where the hardware will be attached, try to maintain a uniform thickness in your tesserae. The lamp hardware includes a decorative washer that covers a portion of the mosaic around the top hole. If the surface is uneven, the pressure on the washer may cause the mosaic to break.

Don't plan on completing a sculptural project in a single day. Because you'll want to turn the piece upside down and set it on its side to examine it from several angles, you should assume at least three or four working sessions with 24-hour drying periods in between.

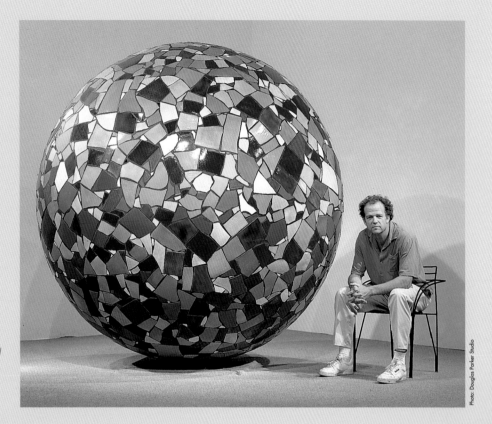

Gifford Myers, *BIG WORLD small planet (for Thom Chambers)*, glazed ceramic tile, 96" (2.4 m) diameter, 1992

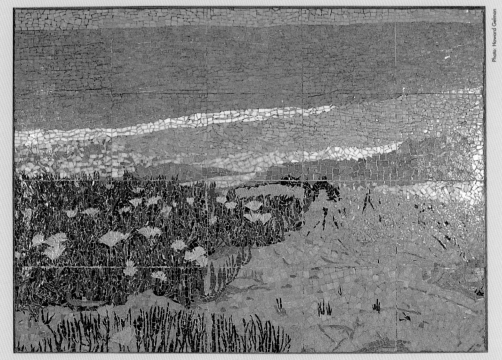

Shelby Kennedy, *Untitled*, Leland Avenue Residence in San Francisco, vitreous glass, 4' x 5' (1.2 x 1.5 m), 1993

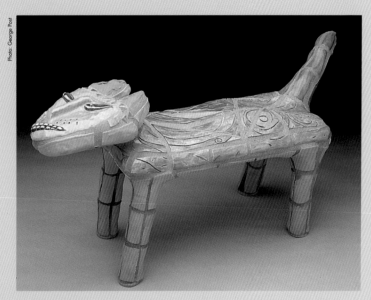

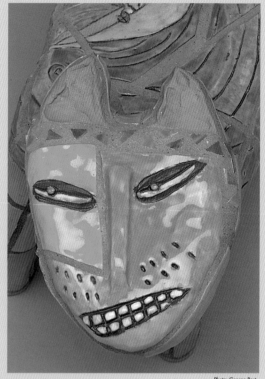

Above: Cathy Raingarden, *Letting Go Cat*, handmade ceramic tile, 13" x 26" x 8" (33 x 66 x 20.5 cm), 1993

Right: Detail of *Letting Go Cat*

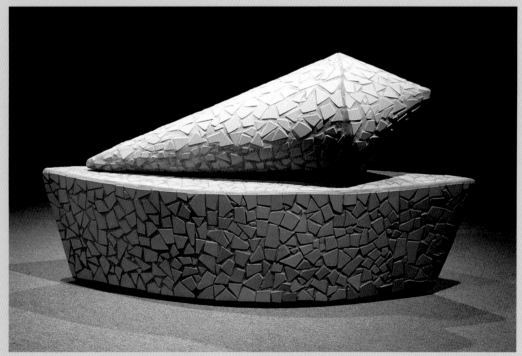

Tom Ashcraft, *Angel*, ceramic tile over steel and concrete, 4' x 7' x 2' (1.2 x 2.1 x .6 m), 1995

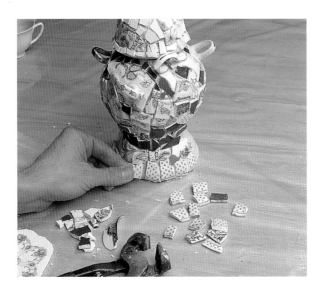

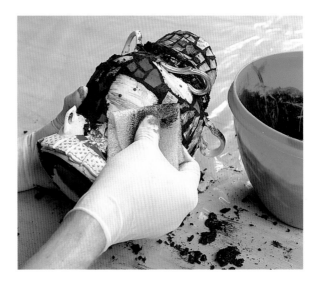

After completing all the major elements of your design, take the time to go over the entire project and fill in any gaps. Make sure you haven't inadvertently covered the hole near the bottom, which must remain open for the electric cord. Then allow your mosaic to dry for at least 24 hours before grouting.

Press the grout into the crevices and wipe away the excess with small pieces of polyethylene foam sheeting (a packing material) or barely damp lint-free rags. On a small project such as this, a rubber grout float is too large and bulky to negotiate the curves. Continue in sections, applying grout and wiping off the excess, until the entire mosaic is complete.

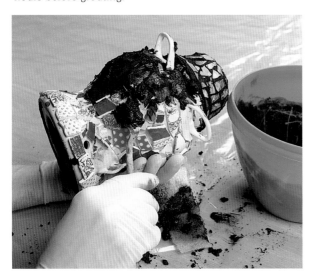

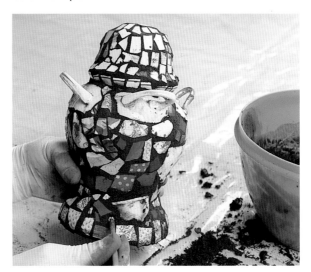

Protecting your hands with rubber gloves, mix a small batch of grout. Start with about a cupful of water and add sufficient dry powder to obtain a thick but smooth consistency. After the grout has cured for about 10 minutes, use a palette knife to apply it to one section of the lamp at a time.

Use a large nail to shape the grout around the holes at the top and bottom. In small concave areas, clean the surface of the mosaic with a stiff toothbrush or a nail wrapped in a dry rag or piece of polyethylene foam sheeting. Remove any remaining grout haze; then allow the lamp to dry thoroughly for at least 24 hours before installing the hardware and wiring.

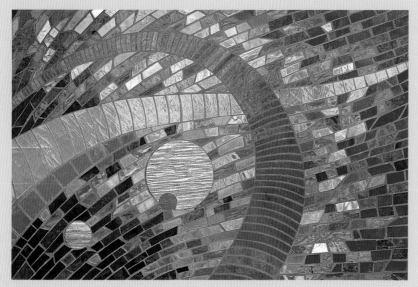

Toby Mason, *Blue-Green Cosmos*, reflective glass, 15" x 23" (38 x 58.5 cm), 1989

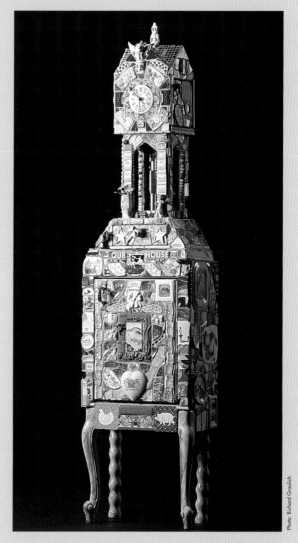

Zoe and Steve Terlizzese, *Home Sweet Home*, broken china, ceramic tiles, glass gems, and ceramic figurines, 66" x 14" x 9" (167.5 x 35.5 x 23 cm), 1996

Photo: Richard Graulich

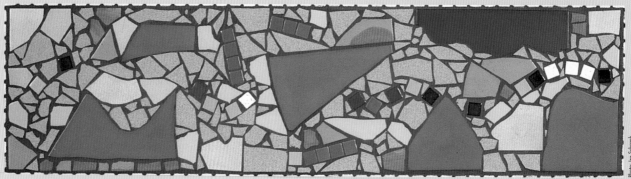

Nancy Gotthart, *Walking the Dog*, ceramic tile, 13" x 48½" (33 x 123 cm), 1995

Photo: Ira Schrank

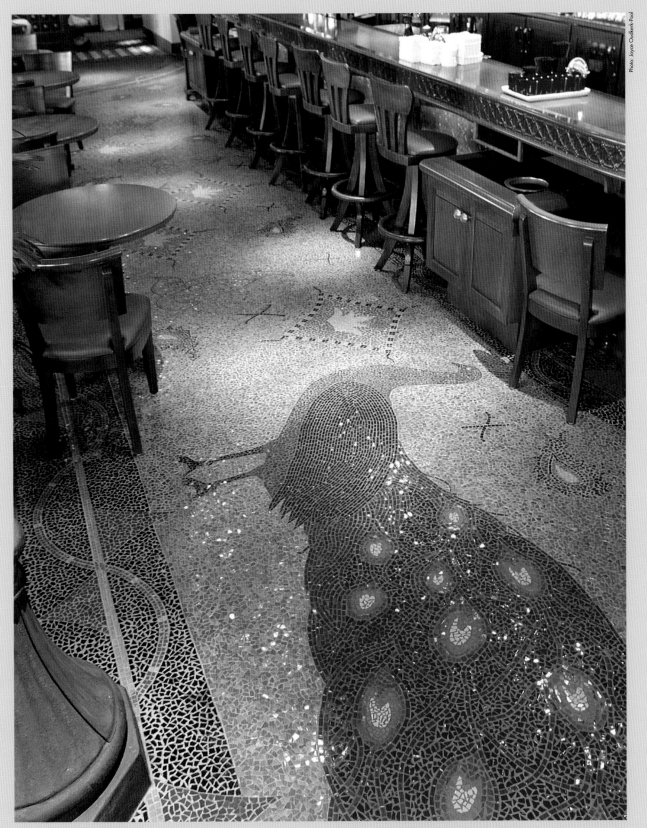

Karen Thompson, The Peacock Floor, bar at the Boulevard, a restaurant in San Francisco, 12' x 50' (3.7 x 15.2 m), 1993

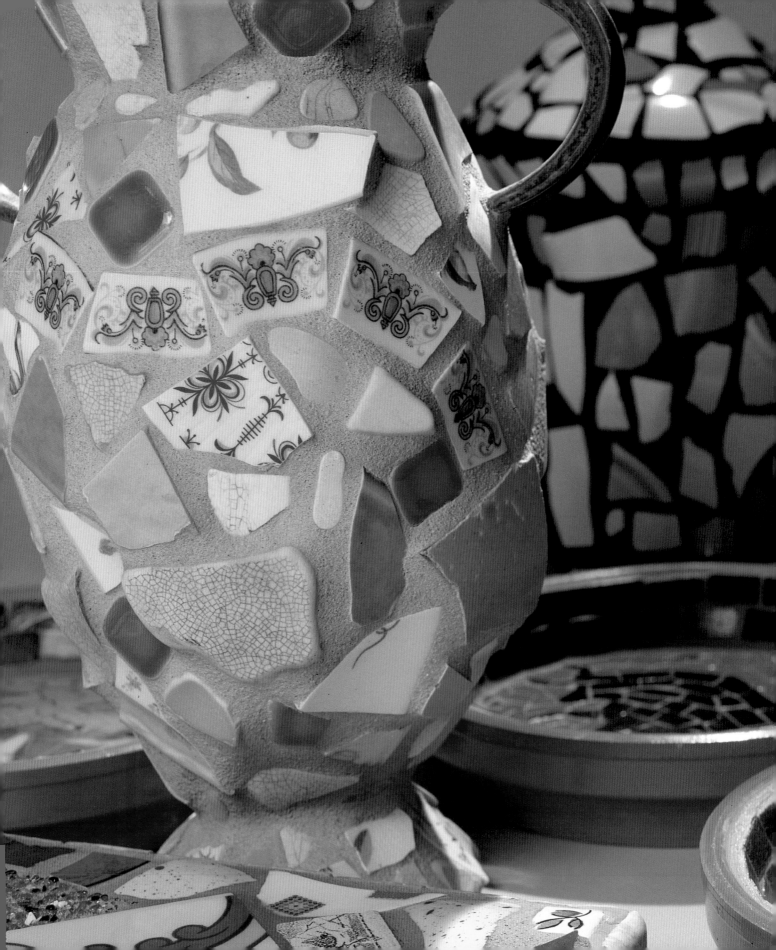

A DOZEN PROJECTS

In the pages that follow, you'll find a dozen projects that demonstrate the variety of materials, tools, and methods that eight different artists use to create their mosaics. As you've probably already noticed, there are very few rules for making mosaics. Each of these artists has developed some favorite approaches; as you make your own projects, explore several to determine what works best for you.

Birdhouse

Design: Terry Taylor

Finished Size: 10½" (26.5 cm) tall

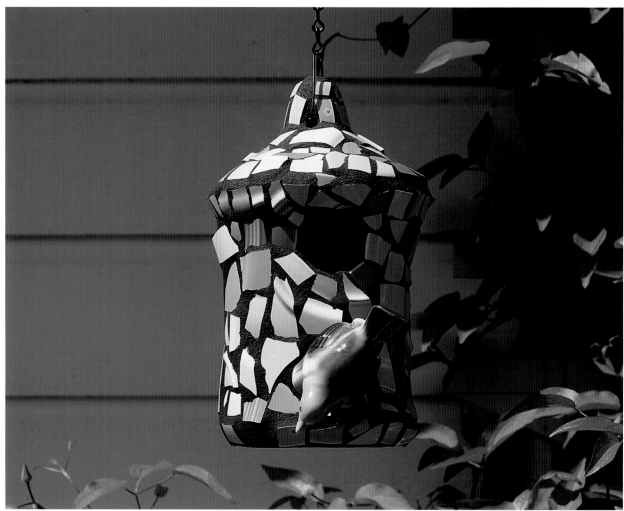

Photo: Evan Bracken

Birds can be fussy tenants and may not wish to make their home in a birdhouse as whimsical or brilliant in color as this. Regardless of their assessment of its housing value, this project makes a delightful accent in your yard or garden. Ceramic figurines such as the bird used here are common fare at flea markets, and local garden centers offer the underlying terra-cotta birdhouse forms. When following the pique assiette method, you can work without a preplanned design and simply let the mosaic develop as you go.

INSTRUCTIONS

1 Using tile nippers, begin cutting irregular pieces from the outer rim of one plate. Work inward toward the center flat portion of the plate; then cut the larger pieces into 1" (2.5 cm) working-size tesserae. Repeat with additional plates until you have a good quantity of irregular tesserae, sorting the pieces by color and degree of curvature.

2 Mix a small amount of cement mortar according to the manufacturer's instructions. Starting with a small amount of water, add dry mortar until you have the consistency of thick mud. Allow the mixture to cure as recommended.

3 In the meantime, decide where you want to place the bird figurine on the birdhouse. In this project it's positioned below the entrance hole, where it can be used as a perch by the inhabitants. Apply some mortar to the area with a palette knife; then butter the base of the figurine. If the bird is hollow and has a hole at the bottom, push some mortar into the hole as well.

4 Position the figurine on the surface of the birdhouse, pressing firmly to make good contact. If you've placed the figurine on a vertical surface of the birdhouse (as shown here), then lay the birdhouse flat, prop it with a scrap piece of wood to prevent it from rolling over, and allow it to dry for 24 hours to ensure the bond.

5 The following day, mix a larger batch of mortar, starting with about a cupful cup of water and sufficient dry mortar to make the proper consistency.

6 Using a palette knife, apply a ⅛" to ¼" (3 to 6 mm) coating of mortar to a small section of the birdhouse around the figurine. Lightly buttering the back of each piece, begin placing larger tesserae. Be sure to allow grout spaces between the pieces, using the edge of your spatula to remove excess mortar from the crevices. Continue applying mortar and tesserae to small areas at a time until the entire surface is covered.

7 Allow the mosaic to dry at least 24 hours.

8 Mix the powdered grout according to the manufacturer's instructions. Using a small square of polyethylene foam wrap or a grout spreader small enough to negotiate the curves of the project, work the grout into the spaces between tesserae. After allowing the grout to set up for about 15 minutes, begin removing any excess material and grout haze using pieces of foam wrap, a barely damp sponge, or lint-free rags. If your birdhouse has a small hole at the top for hanging, use a large nail to remove excess grout from this hole.

9 Allow the project to dry thoroughly before installing it outdoors.

10 During the cold winter months, protect your birdhouse from accumulating moisture—which can cause the terra-cotta to crack when it freezes—by storing it in a sheltered location.

Tools & Materials

- 6-10 Assorted ceramic plates

- Bird figurine with a flat base

- Terra-cotta birdhouse form

- Thinset cement mortar

- Black dry grout

- Tile nippers

- Goggles or safety glasses

- Mixing containers

- Rubber gloves

- Palette knife or small metal spatula

- Scrap piece of wood

- Small grout spreader or polyethylene foam wrap (white packing material)

- Sponge

- Lint-free rags

Two Doves

Design: Joanna Dewfall

Finished Size: 22" x 10" (56 x 25.5 cm)

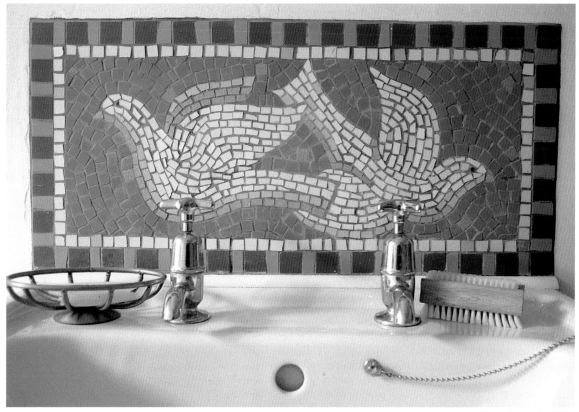

Photo: Joanna Dewfall

Two doves caught in midflight bring an air of serenity to any room or setting; their form and movement are emphasized by the adamento or flow of the tesserae, both in the subject and the background. To create a permanent backsplash, the mosaic is assembled using the indirect method and mounted directly on the wall without a backing board. This approach minimizes the thickness of the piece and makes a more elegant installation.

INSTRUCTIONS

1 Cut the kraft paper into a 30" x 16" (76 x 40.5 cm) rectangle and soak it in water. Stretch the wet paper onto the backing board, securing it with gummed paper tape.

2 When the paper is dry, transfer the design using carbon paper and a dull pencil. Since the finished mosaic will be a mirror image of the working drawing on the kraft paper, you may want to reverse the design before transferring it.

3 Use the nippers to cut a quantity of white and gray tiles approximately into eighths, making some rectangular, some square, and some triangular pieces for the doves' feathers. Cut some white and gray tiles into ¼" (6 mm) squares for the inner border and cut a good amount of medium and light blue tiles into quarters for the background. The outer border consists of full-size terra-cotta tiles alternating with light blue tiles cut in half.

4 Mix a small amount of wallpaper paste and begin the mosaic with the outer border, making certain the tesserae are square and evenly spaced. Follow with the inner border, placing a gold square (gold side down) in each corner.

5 Next complete the doves, using white tesserae for the main portions and gray for shadows. The flow of tesserae should reflect the natural pattern of feathers on a live bird. Use tiny fragments of gold for the eyes, placing these with tweezers.

6 Work the background, starting with a "halo" of blue tesserae around the doves. Continue the undulating flow outward to meet the border, taking care to complete one row before starting another to avoid confusion.

7 After the paste has dried, cut the mosaic off the board. On the back of the paper, draw a swirl of random lines. Then cut the mosaic in half using a crooked cutting line. The random linear pattern on the paper will help you match the two halves when mounting your mosaic on the wall.

8 Prepare your site and materials for installation: score the wall to create a rough surface, mix a batch of polymer-enhanced cement mortar as instructed by the manufacturer, and prepare a watery solution of white glue. Size the wall with the watery glue; then spread the mortar onto the wall, making even passes with a notched trowel to ensure a consistent depth.

9 Using a small trowel, butter the back of one half of the mosaic with mortar and position it on the wall. Repeat with the second section, making sure the two halves are well matched and have a thin grouting space between. Tamp them in place with a wooden block and wipe the edges where any excess cement has squeezed out.

Tools & Materials

- 1" (24 mm) Unglazed ceramic tiles: white, gray, terra-cotta, light and medium blue

- Gold glass tiles

- Temporary backing board somewhat larger than mosaic

- Brown kraft paper

- Gummed paper tape

- Carbon paper

- Wallpaper paste

- White glue (PVA)

- Dry cement mortar with polymer additive

- Gray dry grout

- Tile nippers

- Goggles or safety glasses

- Tweezers

- Glue brush

- Rubber gloves

- Small trowel

- Notched trowel

- Small block of wood

- Mixing containers

- Grout float

- Sponge

- Lint-free rags

Artist's Tip

Always complete one line of background tesserae before starting another to avoid confusion and to maintain the flow of your work.

10 Allow the cement to set for several hours until it's firm; then soak the kraft paper with hot water until it peels off easily. For best results, remove the paper from the top down.

11 Mix the grout with water as recommended by the manufacturer and apply it to the mosaic, using a float to press the grout into all the joints. Remove the excess grout and any remaining haze with a barely damp sponge or lint-free rags.

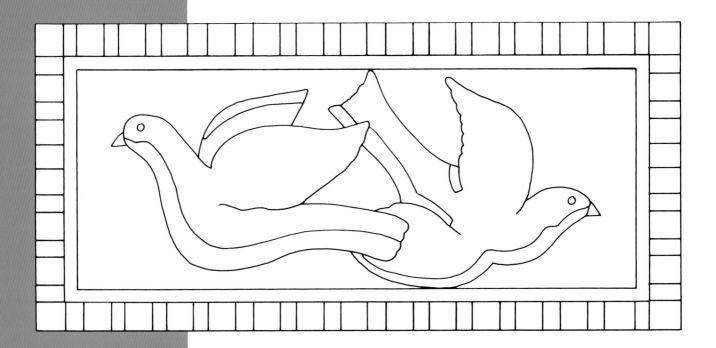

Fish Tile

Design: Jeni Stewart-Smith

Finished Size: 8" (20.5 cm) square

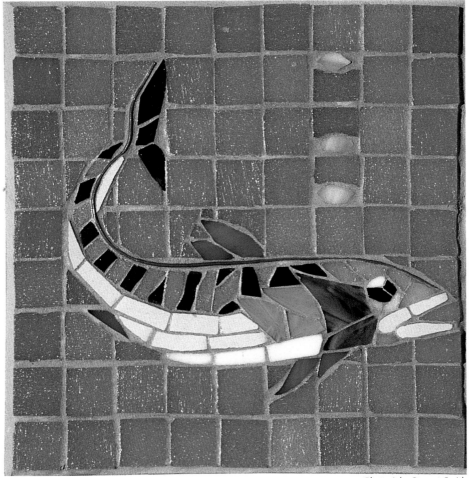

Photo: John Stewart-Smith

The sweeping curve of this graceful fish offers a marked contrast to the
formal regimentation of the background tiles, and the two design elements
are imaginatively linked by a trio of air bubbles. This is an excellent project for
a beginner; it's small in scale, flat, and provides some experience with several materials.
As a finished piece, it makes an excellent trivet or cheese board.

Tools & Materials

- ¾" (2 cm) Vitreous glass tiles: blue, green, yellow, lavender

- 1" (2.5 cm) Ceramic tiles: black, white

- Stained glass: green, red, white

- ½" x 12" (1.5 x 2.5 cm) Lead strip

- 8" x 8" (20.5 x 20.5 cm) Backing board

- White glue (PVA)

- Tile adhesive

- Dry grout

- Tile nippers

- Glass cutter (recommended)

- Goggles or safety glasses

- Sharp knife

- Palette knife or small metal spatula

- Dental probe or tweezers

- Carbon paper

- Scissors

- Needle-nose pliers

- Rubber gloves

- Grout float

- Sponge

- Lint-free rags

INSTRUCTIONS

1 If your backing board is plywood, sand any rough edges and seal the entire piece with a mixture of 50% white glue and 50% water. Once it's dry, draw or trace your design; then score the surface with a sharp knife. If you're working with a cement backing board, sketch or transfer the design directly.

2 Using the tile nippers, cut a quantity of vitreous glass and ceramic tesserae for the fish. You can use tile nippers to cut small pieces of stained glass if you first cut the glass into strips. The nippers tend to nibble the edges of the glass and make unpredictable cuts, however. For more control, use a glass cutter to shape the pieces for the fins.

3 Use the palette knife to apply a thin layer of adhesive to the backing board and the back of each tessera. Working a small area at a time, build up the fish to Line A in the figure. A pair of tweezers or a dental probe is useful for adjusting the pieces as you work. Be sure to leave grout spaces between the tesserae.

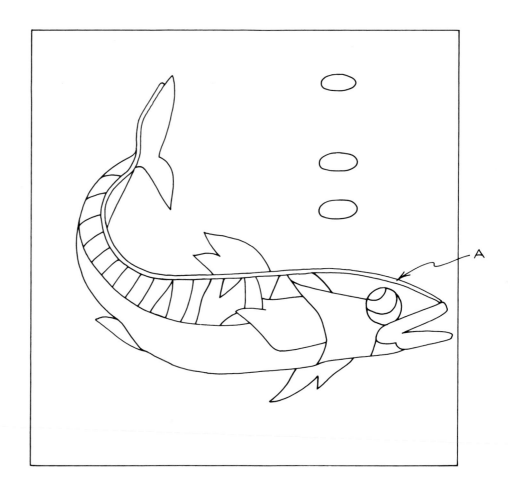

4 Fold the lead strip in half lengthwise, squeezing it together carefully with the pliers to flatten it uniformly. Position the strip, fold uppermost, along Line A from snout to tail. Remember to leave grout spaces on either side of the lead; then complete the tail and remaining fins.

5 The background is done in *opus tessellatum*, using full-size vitreous glass tiles applied in nine rows. For the most effective presentation, make certain that each row is straight and the grout spaces are all fairly uniform. Cut three pieces of stained glass or vitreous glass for the air bubbles and place them as desired.

6 Allow the mosaic to dry for 24 hours.

7 Following the manufacturer's instructions, mix a small batch of grout. Spread the grout over the mosaic, working it into all the crevices with a float. Apply an even amount of grout along all four edges of the mosaic to make a beveled edge with the backing board. Using a slightly damp sponge or lint-free rags, remove the excess grout and any haze on the surface.

Artist's Tip

When cleaning up after working with cement products, such as grout, rinse your hands thoroughly in vinegar before washing them with soap and water. The alkalinity of the cement is neutralized by the vinegar's acidity, restoring the pH balance of your skin. Remember not to throw the water from your grout-filled sponge into your sink; the sand will clog the drain.

Mister Mooch

Design: George Fishman
Finished Size: 17½" x 22" (44.5 x 56 cm)

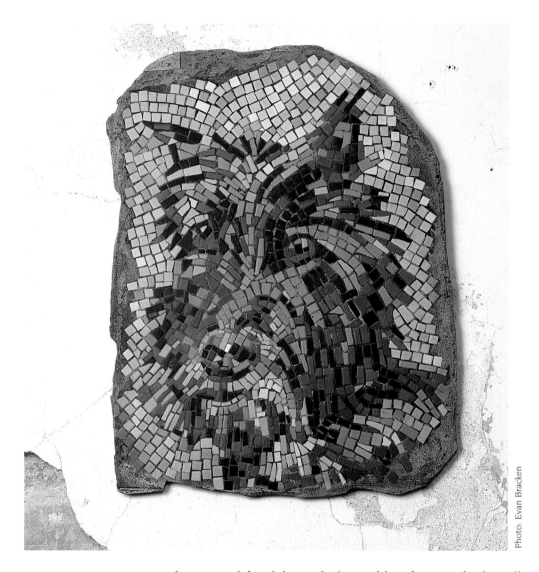

Photo: Evan Bracken

Mister Mooch is a mixed-breed dog with plenty of hair bursting forth in all directions and just as much personality. In keeping with both, the artist rendered his subject in a very loose, impressionistic style. The method used to create the mosaic is largely self-grouting (i.e., the mortar fills many of the grout joints), so you should choose a mortar and grout that match each other in color.

INSTRUCTIONS

1 Sketch your design or enlarge the figure to the size desired and tape it face up on your work surface. Then cut enough paper-backed clear film to cover the entire drawing and secure it, sticky side up and minus the paper backing, over the image.

2 After cutting a quantity of tesserae, begin assembling the mosaic on the adhesive film. Define the outer edges of the dog and his key features—eyes, nose, and mouth. To obtain the loose and open style shown here, mix some other colors in with the black and brown tesserae used to outline the features.

3 Fill in the dog's face and shoulders, cutting many of the tesserae into long, narrow shapes and placing them in lines to suggest the flow of hair. The background tesserae echo the flow of hair. Continue the lines outward, leaving ragged edges all around.

4 When the design is complete, apply the high-tack film adhesive side down onto the mosaic. If necessary, use two pieces of film to cover the entire mosaic. Using a dry rag, rub the surface of the film to adhere all the tesserae. Then trim the film to match the mosaic.

5 Turn over the mosaic, holding it firmly between two boards to steady it, so that the bottom surface now faces up. Fold the low-tack film back on itself and gently peel it off the mosaic.

6 Use a jigsaw with a carbide blade to cut the cement backing board into an irregular shape a little larger than the mosaic. Save a scrap to use later as a test sample. Then, using a masonry bit about ¼" (6 mm) in diameter, drill two holes through the backing board at the appropriate locations for a wire hanger.

7 Mix a batch of cement mortar as instructed by the manufacturer, using a brand that is already polymer enhanced or adding the polymer as a separate ingredient for extra strength. While the mortar cures briefly, assemble a test sample of tesserae on a scrap piece of high-tack film. Then moisten the backing board with a damp sponge.

8 Using a rubber grout float, apply a thin coating of mortar to the mosaic. If a few tesserae become dislodged in the process, just pick them out with tweezers. They can be replaced later using the direct method.

9 Stuff the holes in the backing board with paper; then apply an even coating of mortar to the entire surface with the smooth edge of a notched trowel. Use the notched edge to go over the mortar and set the depth.

10 Lift the film-mounted mosaic and set it carefully onto the backing board. Try to place it accurately, but don't lift it to try again if you're a little off center. The alignment is less critical when you have an irregularly shaped plaque with "blank" space around the mosaic.

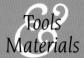

Tools & Materials

- 1" (2.5 cm) Unglazed porcelain tiles: browns, grays, greens, blues, black, beige
- Paper-backed clear adhesive film
- High-tack clear adhesive film
- Thin cement backing board
- Heavy braided mirror-hanging wire
- Polymer-enhanced dry cement mortar
- Polymer-enhanced dry grout
- Tile nippers
- Goggles or safety glasses
- Tweezers
- Jigsaw with carbide blade
- Electric drill with 1/4" (6 mm) masonry bit
- Rubber gloves
- Grout float
- Notched trowel
- Sponge
- Stiff toothbrush
- Nylon scouring pad
- Lint-free rags

Adjust the placement if necessary by tamping the mosaic with glancing blows of the rubber float.

11 Starting in the center and working outward in a spiral, beat the surface evenly with a clean rubber float to cre-

ate a good bond. When you're done, remove any excess mortar that may have squeezed out along the edges. Repeat the process with your test sample; then allow both to dry for several hours.

Artist's Tip

No matter what style you prefer, find some close-up photographs of Roman mosaics and try copying some details. Although you'll ultimately need to learn everything in your own terms, working intimately with masters of the medium will increase your appreciation of the flow of your own designs and inspire your creativity.

14 Mix a batch of polymer-enhanced grout that matches the color of your mortar. Apply the grout to the mosaic, pressing it into the surface with the float. After waiting about 10 or 15 minutes, wipe off the excess grout and haze with a damp nylon scrubbing pad. Continue to polish the surface with dry rags until it's clear of grout film. Then allow the mosaic to cure for at least a day.

15 To stucco the blank area around the mosaic, first cover the mosaic with clear adhesive film to keep it clean. Then mix some matching grout and apply it to the blank area and the edges of the plaque. Trowel on sufficient material to cover the backing board and match the thickness of the mosaic. Allow the grout to dry 24 hours.

16 Remove the paper stuffing from the holes in the backing board. To attach a hanger, make a knot at each end of a length of heavy braided wire. Apply a liberal amount of epoxy to the knots and insert them into the holes in the backing board.

12 Test the sample by carefully peeling off the film. When the test shows a good bond, check the mortar with a fingernail or pencil; it should be firm but capable of being dented. Then gently remove the film from the face of the mosaic.

13 Brush the surface of the mosaic with a stiff toothbrush or bristle brush to accentuate the grout joints. Scrubbing in a circular motion, cover the entire surface evenly; then remove the excess mortar with a damp sponge.

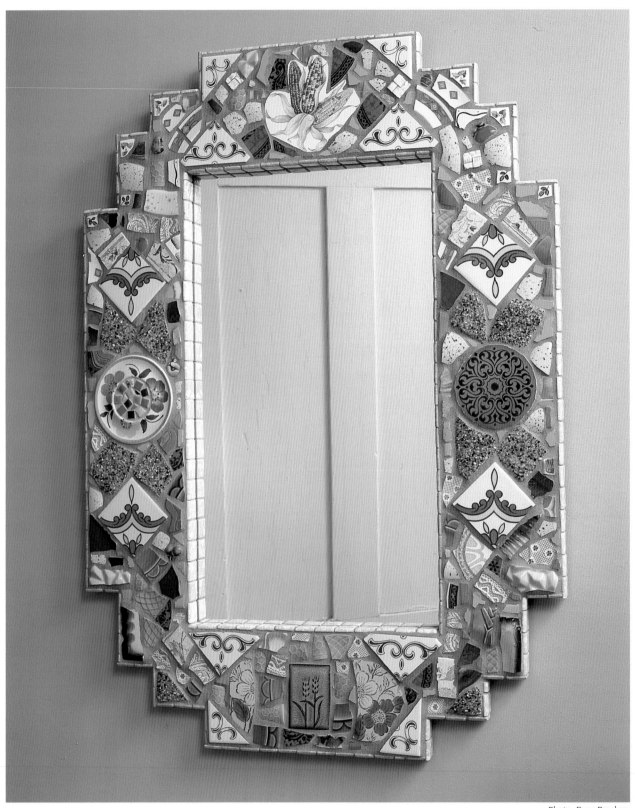

Photo: Evan Bracken

Mirror Frame

Design: Zoe & Steve Terlizzese

Finished Size: 26" x 36" (66 x 91.5 cm)

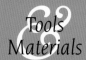

Who says that mirrors have to be all business and no fun? This one is guaranteed to put you in a good mood every time you comb your hair. From its stair-stepped corners to its eclectic mix of colorful materials, the sheer energy of this contemporary pique assiette design will chase away even the worst Monday-morning blues.

- Assortment of colorful dishes, tiles, and miscellaneous ceramic pieces
- 1" (2.5 cm) Bull-nosed tiles
- ¾" (2 cm) High-density particle board
- Wood sealant
- Tile adhesive
- ¼" (6 mm) Mirror to fit your frame
- Brown kraft paper
- White glue (PVA)
- Dry grout
- Acrylic paint to match grout
- Braided mirror-hanging wire
- Eye screws
- Tile nippers
- Tile cutter (for larger pieces)
- Jigsaw
- Palette knife or small spatula
- Mixing container
- Rubber gloves
- Grout sponge
- Lint-free rags
- Paintbrush
- Craft or mat knife

INSTRUCTIONS

1 Using a jigsaw, cut the particle board into the desired shape for your mirror frame. Be sure to use high-density particle board, which has a high resin content and is less likely to warp, or substitute exterior-grade plywood. Then seal all surfaces, including all the edges, with wood sealant.

2 Cut a quantity of tesserae, using the tile cutter for larger flat pieces and nippers for the others. To develop your design, arrange the main pieces around the frame—without any adhesive—until you're happy with the result. Then apply a thin layer of tile adhesive to the wood and butter the backs of the larger tesserae to fix them in place. Fill in the gaps with smaller pieces, making sure to allow grout spaces between tesserae. Remove any excess adhesive with the edge of the palette knife.

3 When your design is complete, set the frame on a flat, hard surface and apply the 1" (2.5 cm) bull-nosed tiles around the inside and outside edges. The flat bottom edges of the tiles should be even with the bottom surface of the frame.

4 Allow the frame to dry for 24 hours. Then mix the grout as instructed by the manufacturer and apply it to the surface of the mosaic. The designers advocate using your gloved hands to press the grout into the crevices between tesserae, but you may prefer to use a rubber float or other tool. Remove the excess grout with a barely damp sponge; then polish the surface with dry soft rags.

5 When the grout is dry, paint the inside edge of the back of the frame using a paint that is close in color to your grout. If this isn't done, the raw wood on the back of the frame will reflect around the edges of the mirror.

6 Your mirror should be slightly larger than the inside opening of the frame to allow an overlap of about 1" (2.5 cm) all around. Place the mirror over the opening and glue it in place. (A strong acrylic tile adhesive works well for this purpose.) Allow the adhesive to dry thoroughly.

7 Run a bead of white PVA glue around the outer perimeter of the back of the frame, placing the glue about ¼" (6 mm) in from the edge. Smooth the glue with your finger; then cover the back of the frame with brown kraft paper. Using a craft or mat knife, trim the paper around the edges.

8 Install two eye screws, placing them about a third of the way down from the top of the frame, and attach the wire to the screws.

Flamingo

Design: Martin Cheek

Finished Size: 26" (66 cm) diameter

Photo: Martin Cheek

The inspiration for this mosaic was born during a visit to the zoo by the artist and his young son. When the boy caught sight of a flamingo he remarked, "Daddy, look at that bird sitting on a stick!" The flamingo in this design shares the family joke; his leg looks more like a prop than a proper limb. The instructions call for using the direct method, but if you're feeling a bit uncertain, try the indirect method instead.

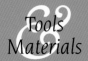

Tools & Materials

- Vitreous glass tiles: pink vein, pink, white, bronze, black, various grays, blues, and blue-green hues

- Backing board

- White glue (PVA)

- Tile adhesive

- Dry grout

- Tile nippers

- Goggles or safety glasses

- Glue brush

- Carbon paper

- Sharp knife

- Small trowel

- Mixing container

- Rubber gloves

- Grout float

- Sponge

- Lint-free rags

INSTRUCTIONS

1 Cut your backing board into a 26" diameter (66 cm) circle. If you're using plywood, sand any rough edges and seal all the surfaces with a mixture of 50% white glue and 50% water. Allow the board to dry completely. Then sketch or transfer the design to the board and score the surface with a sharp knife or hacksaw blade. If you're using a thin cement backing board, sketch or trace the design onto it after cutting.

2 Use the tile nippers to cut a quantity of ⅜" (1 cm) square tesserae, sorting the pieces by color.

3 Begin the mosaic by creating the key line of the flamingo's back and neck in white and gray tones. This line plays a major role in the overall design, and it's important that you make a clear, strong, flowing line. Apply a thin layer of adhesive on the backing board and butter the back of each tessera before placing it. Be sure to leave grout spaces between tesserae.

4 Continue to fill in the flamingo's body, cutting triangular tesserae as needed to emphasize the feathers on its wing and tail. Use bits of gray as shadowing and include a few pale pink tesserae in the upper body to create greater depth and dimension. When working the facial features, make your cuts more precise and use smaller tesserae for a realistic effect.

5 Once you've finished the flamingo, place a single line of blue tesserae in a "halo" all around the bird and most of the way down its leg.

6 Now shift your attention to the background and outer edge of the mosaic. If desired, finish the raw edge of the plaque by placing a line of tesserae all around. Remember to leave grout spaces between tesserae.

7 One of the interesting features of this mosaic is the sky in the background, which radiates outward from the center in concentric circles. To achieve the perfect circles shown here, begin by placing the outermost border of bronze tesserae. Position these pieces slightly inward from those just attached to the outer edge so that there's sufficient room for grout in between. Then work *inward* toward the center. Using the more conventional approach of working outward from the subject is much likelier to produce noticeably out-of-round circles by the time you reach the perimeter.

8 Place the pool of water at the base of the mosaic, laying the colors to create the effects of ripples on the surface. With several rings of color centered around the flamingo's leg, it appears that he just stepped into the water to take a drink.

9 When the mosaic is complete, allow it to dry at least 24 hours.

10 Mix the powdered grout as directed by the manufacturer; then spread it over the entire surface and edges of the plaque. Using a grout float, carefully work the material into all the crevices. Remove any excess grout and haze using a barely damp sponge or lint-free rags.

Planter

Design: Terry Taylor

Finished Size: 10" x 7" x 7¼" (25.5 x 18 x 18.5 cm)

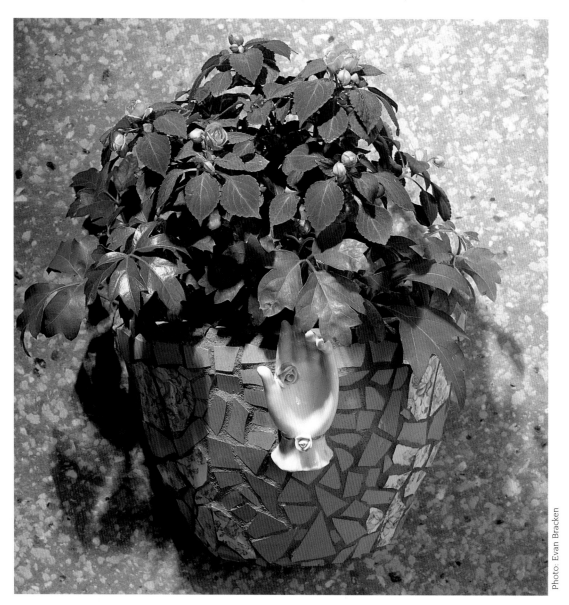

Photo: Evan Bracken

You don't need to be an expert gardener to appreciate the appeal of this elegant wall planter. The design is simple yet sophisticated, and the palette of soft pastels complements even the most common of houseplants. Using the pique assiette technique, this project can be completed in less than a week—just enough time to select which plants deserve the honor of a new home.

INSTRUCTIONS

1 Purchase a terra-cotta planter in the desired size at any local garden center. Flea markets are excellent sources for plates, figurines, and decorative elements such as the hand-shaped ring holder used on this project. When selecting your plates, keep a color theme in mind; this planter uses a combination of solid and floral-patterned materials.

2 Beginning at the outer rim and working toward the flat center, use tile nippers to cut the plates into irregular tesserae. Don't worry about the size of the pieces at this point; some will be larger than others. You can reduce their size as you go along and see what you need.

3 Sort the tesserae according to color and contour, holding the curved pieces aside for places where they fit best.

4 Mix a small batch of cement mortar according to the manufacturer's instructions, allowing it to cure briefly as directed. Then use a palette knife to apply a small amount of mortar to the area of the planter where you wish to place the hand-shaped ring holder and to the back of the hand. Press the hand firmly onto the planter, smoothing any excess mortar that squeezes out by spreading it outward onto the surface of the planter.

5 Using the hand as a focal point, add a ⅛" (3 mm) coating of mortar around it and begin placing the tesserae, buttering the back of each piece before placing it. Continue the mosaic in a random arrangement of color and pattern or in a simple pattern such as the one shown on this project. Be sure to leave grout spaces between the tesserae. Using the edge of your palette knife, remove any excess mortar that squeezes up to the surface of the mosaic.

6 When the outside of the planter is complete, allow it to dry for 24 hours.

7 Using whatever means are handy, prop up the planter so that you can work on the top edge. Then mix a small amount of mortar and complete the rim of the planter with mosaic.

8 Allow the planter to dry 24 hours before grouting.

9 Mix the grout according to the manufacturer's instructions and apply it to the surface of the planter with a small piece of polyethylene foam wrap or a grout float. Remove the excess grout and use a barely damp sponge or lint-free rags to wipe off any haze from the surface.

10 If you display your planter outdoors, protect it during the winter months by not allowing it to accumulate moisture. As the planter alternately freezes and thaws, trapped moisture can cause the terra-cotta to crack. Place the planter upside down in a protected location or bring it indoors for the winter.

Tools & Materials

- 6-10 Ceramic plates
- Hand-shaped ring holder
- Terra-cotta wall planter
- Thinset cement mortar
- Light gray dry grout
- Tile nippers
- Goggles or safety glasses
- Mixing containers
- Palette knife or small metal spatula
- Grout float or polyethylene foam wrap (white packaging material)
- Sponge
- Lint-free rags

Fire Salamander

Design: Martin Cheek

Finished Size: 18" (46 cm) square

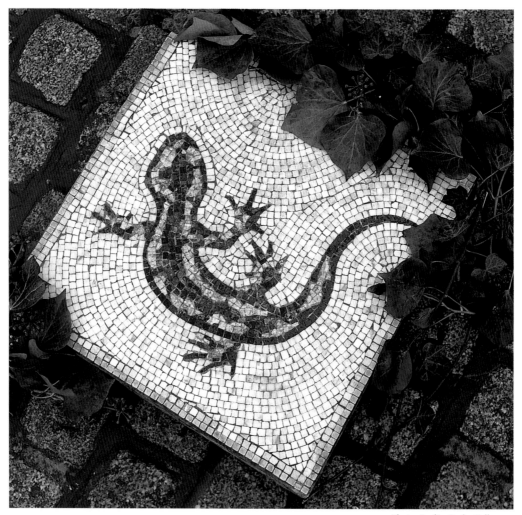

No garden is complete without a few amiable lizards to bring a smile to your face. This colorful creature—with his jet black body and flaming Van Gogh yellow patches—is a native of the Ardèche in southern France. He's immortalized on the face of a stepping stone, which makes a winsome addition to the entryway of your house or a sunlit corner in your garden. The mosaic is done using the indirect method, and the paver is cast in cement.

INSTRUCTIONS

1 Cut a piece of kraft paper slightly larger than the mosaic, moisten it, and stretch it onto the backing board, holding the paper in place with strips of gummed paper tape. Then enlarge the salamander design to the desired size and transfer it onto the kraft paper using carbon paper and a dull pencil. Since the finished mosaic will be a mirror image of the working drawing, you may wish to reverse the design before transferring it.

2 Using the nippers, cut a quantity of granite and marble tesserae into cubes about ⁵⁄₁₆" (8 mm) on each side. When you have enough material accumulated, mix a small batch of wallpaper paste.

3 Begin the mosaic by forming the outline of the salamander's back. Remember that the finished surface of the mosaic is the one that touches the paper, so examine each cube carefully, apply the paste to the desired surface, and place it face down on the paper. Adjust the placement of tesserae with the tweezers and allow small gaps between pieces for the grout.

4 Continue to mosaic the salamander's body, nibbling the yellow marble tesserae into appropriate shapes to create the mottled skin pattern. Shape the tesserae into more angular pieces to form the feet and tail.

5 When the salamander is complete, outline the figure in a single line of white marble tesserae. Then form the border of the stepping stone in two rows of straight lines. Fill in the background area by following the flow of the key line of the salamander's back.

6 Construct a mold for the stepping stone by attaching four wooden boards to the paper with white glue. Set the boards on edge about ¼" (5 mm) from the border of the mosaic and screw them together at the corners so that the weight of the concrete doesn't collapse the mold. Then paint a mixture of 50% petroleum jelly and 50% mineral spirits on the inside surface of the wooden frame; this acts as a release agent when you unmold the paver.

7 Sprinkle a small amount of sharp sand into the crevices of the mosaic to prevent the concrete from flowing underneath the tesserae and onto the surface of the mosaic.

8 Combine equal amounts of sand and cement in a large bowl. When they're thoroughly mixed, make a well in the center and gradually add water until the concrete has the consistency of thick mud. Pour the mixture into the mold, filling it halfway. Then tap the sides of the frame with the handle of the trowel to settle the concrete. Add the wire mesh and complete the pour to fill the mold. After tapping the sides once more, smooth the surface of the concrete with the trowel.

Tools & Materials

- White and yellow marble tiles
- Black granite tiles
- Temporary backing board somewhat larger than mosaic
- Brown kraft paper
- Gummed paper tape
- Carbon paper
- Wallpaper paste
- ¾" x 1½" (2 x 4 cm) Wood framing to fit mosaic
- Petroleum jelly
- Mineral spirits
- White glue (PVA)
- Sand
- Cement
- Galvanized wire mesh cut to fit mosaic
- Dark gray dry grout
- Tile nippers
- Goggles or safety glasses
- Glue brush
- Tweezers
- Screwdriver and wood screws
- Rubber gloves
- Trowel
- Mixing containers
- Toothbrush
- Grout float
- Sponge
- Lint-free rags

9 Allow the concrete to harden for at least a week; then unscrew and remove the wooden frame. Turn over the slab and remove the backing board. After soaking and removing the paper, use an old toothbrush to remove any loose sand from the crevices.

10 Following the manufacturer's instructions, mix a small batch of powdered grout and apply it to the mosaic using a float. Remove any grout haze and polish the surface of the mosaic with lint-free rags.

Artist's Tip

Be kind to your mistakes. If you get it wrong, don't worry. You'll get it right next time.

Seaside Treasures

Design: Joanna Dewfall
Finished Size: 26" x 18" (66 x 45.5 cm)

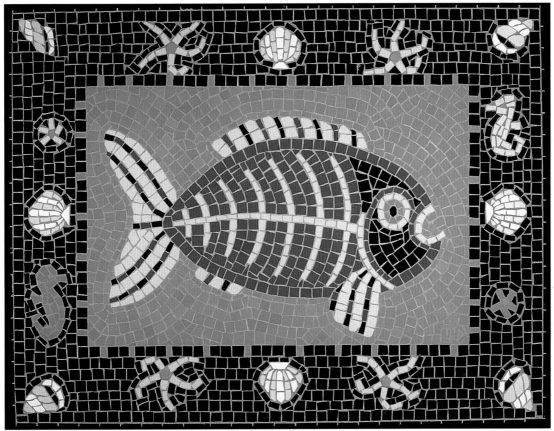

Photo: Derek Magrath

Sounds of the sea and intoxicating visions of whiling away a lazy day at the beach will fill your mind every time you glance at this cheery mosaic. If you can't spare the wall space for a hanging plaque, it makes an impressive serving tray for hors d'oeuvres or after-dinner treats. The ordered regularity of the border effectively contains the exotic-looking fish, which is caught in a moment of stillness within the churning water. The design is carried out using the direct method.

INSTRUCTIONS

1 If you're using plywood for your backing board, sand any rough edges and seal all surfaces with a mixture of equal parts of white glue and water. After it has dried, draw or trace the design onto the board and score the surface with a sharp knife. If you're using a cement backing board, simply sketch or transfer the design.

2 Precut a number of black tiles into ¼" (6 mm) squares for the border and cut batches of several colors approximately into eighths for the motifs. For the fish, cut a quantity of terra-cotta and yellow tiles into quarters.

3 Apply a thin layer of tile adhesive to the border area and lay a line of black squares around the outer edge of the backing board, buttering the back of each

piece before placing it. Allow grout spaces between tesserae and make sure to leave a $1/16$" to $1/8$" (2 to 3 mm) gap from the very edge (i.e., not flush) so that when the "framing" tesserae are applied to the edges there will be enough space for grouting.

4 Using the smaller pieces, create the shells, starfish, and sea horses. Then surround each motif with a line of black.

5 Outline the central fish with terracotta squares; then use pale yellow pieces to form the mouth, eye, gill, and fish-bone pattern. After filling in the main body of the fish, begin the background sea by placing a "halo" of blue around the fish. Complete the background in blue with a sprinkling of green for added texture.

6 When the design is complete, lay the mosaic face down on a clean surface. This will ensure that the top surfaces of the framing tesserae will be flush with the face of the mosaic. Cut to size a quantity of black tesserae and apply the pieces to the edges, allowing small gaps for the grout. For added strength, overlap the corners.

7 Allow the mosaic to dry at least 24 hours.

8 Mix the powdered grout as directed by the manufacturer; then spread the grout over the entire surface of the mosaic, working it into the crevices with a float. Make sure the edges and corners are well grouted before wiping off the excess. Using a barely damp sponge or clean rags, polish the surface to remove any haze.

Artist's Tip

When filling in the area surrounding each motif—even small border patterns—take care with the directional flow of your tesserae. Stagger the lines to avoid creating any "rivers" across the flow, since these may detract from your design.

Tools & Materials

- 1" (24 mm) Unglazed ceramic tiles in terracotta, pale yellow, green, white, off-white, blue, and black

- 26" x 18" (66 x 45.5 cm) Backing board

- White glue (PVA)

- Tile adhesive

- Dry grout

- Tile nippers

- Goggles or safety glasses

- Glue brush

- Carbon paper

- Sharp knife

- Tweezers

- Spatula or small trowel

- Mixing container

- Rubber gloves

- Grout float

- Sponge

- Lint-free rags

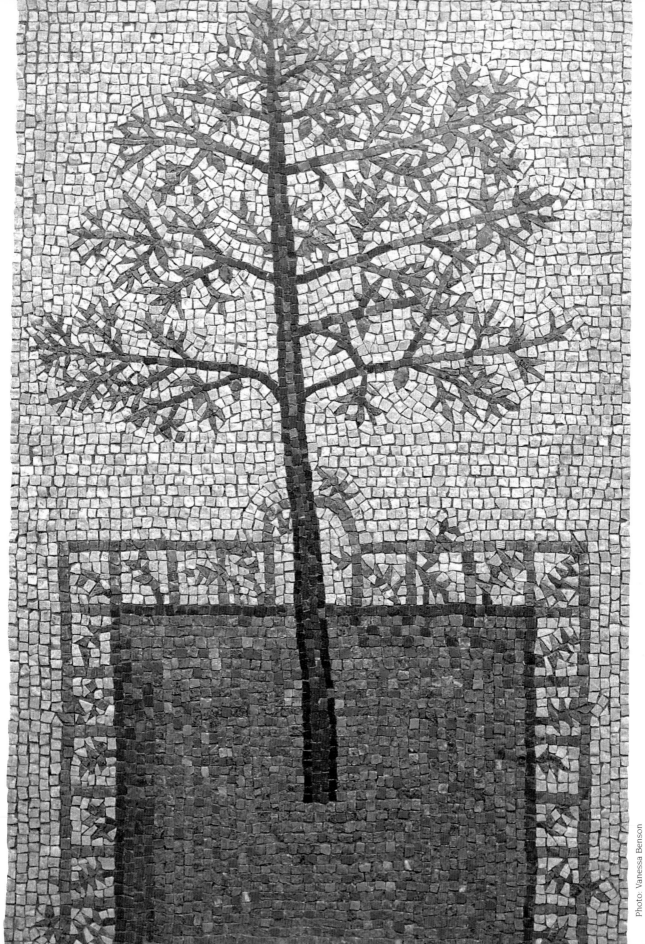

Tree & Maze

Design: Vanessa Benson

Finished Size: 23" x 14½" (58 x 37 cm)

Reminiscent of a medieval tapestry, this design combines the precise geometry of a garden maze with the organic form of a living tree. If you find it daunting to work with such small tesserae (these are ¼"/5 mm), simply scale up the design or simplify the maze. The instructions for this project, which is done using the indirect method, provide an opportunity to apply the grout and cast the backing plaque all in one operation.

INSTRUCTIONS

1 Cut a piece of kraft paper slightly larger than the mosaic and wet it thoroughly in water. Stretch the moist paper on a backing board, securing the edges with gummed paper tape. Allow it to dry in place.

2 Sketch a design or enlarge the figure to the desired size; then transfer the design onto the kraft paper using carbon paper and a dull pencil. Since the finished mosaic will be a mirror image of your working drawing, you may wish to reverse the design before transferring it.

3 Using the nippers, precut a good amount of tesserae into ¼" (5 mm) squares for the maze and trunk of the tree. Cut small triangles of green marble for the leaves.

4 Mix a small amount of wallpaper paste or make a flour paste by adding some water to two spoonfuls of flour. The flour paste should have the consistency of milk and must be stirred over heat until it thickens. Use either adhesive to apply your tesserae, keeping in mind that the face applied to the paper will be the surface visible in the finished mosaic.

5 Begin in one area and work outward, leaving small gaps between tesserae for the grout. In this mosaic, the application of the background pieces in uniform rows complements the geometry of the maze and adds to the serenity of the design.

6 When the entire design is complete, make a mold by placing the wooden boards around the mosaic, leaving a gap of 1⁄16" (2 mm) all around. Use corner clamps or wood screws to fasten the corners. After

- Marble tiles in brown, green, and beige tones
- Unglazed ceramic tiles in complementary dark brown
- Brown kraft paper
- Two temporary backing boards somewhat larger than mosaic
- Gummed paper tape
- Carbon paper
- Wallpaper paste or flour
- ¾" x ¾" (2 x 2 cm) Wood framing to fit mosaic
- Petroleum jelly
- Galvanized wire mesh
- Fine sharp sand
- Cement
- Tile nippers
- Goggles or safety glasses
- Pointed tweezers
- Glue brush
- Corner clamps or screwdriver and wood screws
- Rubber gloves
- Mixing containers
- Sieve
- Wire cutters
- Large and small trowels
- Grout float
- Sponge
- Lint-free rags

9. In another container, mix five parts of unsifted sand with two parts of cement and add just enough water to make a stiff, mudlike consistency. Adding too much water weakens the setting. Trowel the mortar onto the grouted tesserae, filling the mold halfway. Add the wire mesh; then fill the mold with mortar, paying special attention to corners and edges.

10. After leveling the surface of the mortar with a large trowel, sprinkle a little dry cement onto the wet surface. Clean the mold with a damp sponge, place a sheet of newspaper over the mortar, and add the other backing board on top.

11. Holding both backing boards tightly together, turn over the mosaic and lay it flat on your work surface. Remove the top backing board and dampen the kraft paper. Then beat the surface firmly with the grout float. This encourages the grout to come up to the surface. Wet the paper thoroughly and leave it for about 10 minutes.

12. Gently peel off the paper, checking that no tesserae become dislodged. If any piece does get disturbed, add a bit of mortar to the hole, replace the tessera, and tap it gently with the underside of the trowel until it's level with the surrounding pieces. Grout any gaps with mortar.

13. Carefully clean the mosaic with an almost dry sponge, rinsing the sponge frequently in clean water and wringing it well. Then burnish the surface with clean, dry rags.

14. Leave the mosaic to dry for a week, placing a wet cloth and a few weights on the surface. When it has dried thoroughly, remove the wooden mold.

rubbing a small amount of petroleum jelly on the inner surface of the mold, place it in position around the mosaic on the backing board. (The lubricant will make it easier to remove the mold later.)

7. Cut the wire mesh to fit inside the mold, cutting it ⅜" (1 cm) smaller all around.

8. In a bowl, mix five parts of sifted sand with two parts of cement for the grout. Add water until the mixture has the consistency of thick syrup. Sprinkle some dry sifted sand over the mosaic, slightly filling the spaces between tesserae. Place some grout onto the mosaic and press it into the crevices with a small trowel. Remove any excess.

Classic Urn

Design: Cathy Raingarden

Finished Size: 10" (25 cm) high

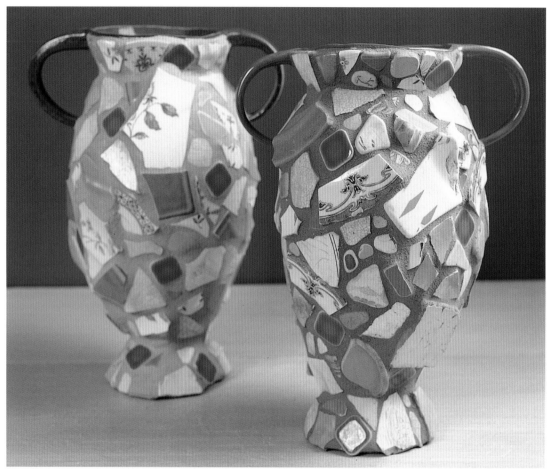

Photo: Evan Bracken

When creating sculptural mosaics, you can often produce the best effects if you choose objects that are simple in shape. The gentle curves of this two-handled urn invite an admiring eye but don't steal all the attention from the mosaic itself. The underlying form may also influence how you design your mosaic. In this composition, a combination of antique china and modern tiles reflects the timelessness of the urn.

INSTRUCTIONS

1 Place the plates between thick layers of newspaper and smash them with a hammer. The newspaper should contain the flying shards, but make sure to wear safety glasses just in case. If desired, use the tile nippers to make some more specific cuts.

2 Part of the allure of this project is its tactile quality. Some of the tesserae appear almost as though they've been weathered by the sea. To smooth the edges of the tesserae you plan to use, moisten the whetstone and rub it back and forth against the sharp edges.

3 When you have plenty of tesserae, small and large, mix a small amount of cement mortar. Use a brand that already includes a polymer additive or add the polymer yourself to strengthen the adhesive for use on a three-dimensional surface.

4 If you're working on a terra-cotta urn or vase, dampen the surface with a moist sponge. Terra-cotta is very porous and will leach the water out of the mortar too quickly.

5 Using a palette knife or small spatula, apply a coating of mortar onto a small area of the urn. Lightly butter the back of one of the smooth shards and press it firmly onto the urn. Some mortar should ooze up from underneath, indicating that you have sufficient adhesive in place. Repeat with additional tesserae, leaving spaces between them for the grout. In this mosaic, the artist has made the grout joints quite large, giving more emphasis to the individual qualities of the tesserae. Continue working until you have covered the entire urn or until you reach a natural stopping point.

6 Using a barely damp sponge, gently wipe off any smudges of mortar on the tesserae.

7 Allow the mosaic to sit undisturbed for about an hour. Then use the small carving tool and scrape off the firm but still workable mortar from between the tesserae. After wiping off any remaining traces of mortar with a barely damp sponge, allow the mosaic to dry for 24 hours.

8 Mix a small batch of grout as instructed by the manufacturer. The working consistency should be very thick but smooth. Wearing rubber gloves, apply a handful of grout to the urn, rubbing it with your fingers into the crevices between tesserae. After the entire urn is grouted, remove any excess material with a slightly damp sponge. Allow the grout to cure for a couple of hours; then polish off any remaining haze with a piece of cheesecloth or dry lint-free rags.

Tools & Materials

- 8-10 Assorted small plates
- A handful of contrasting glazed tiles
- Newspapers
- Terra-cotta or ceramic urn or vase
- Polymer-enhanced dry cement mortar
- Pale green dry sanded grout
- Hammer
- Tile nippers (optional)
- Goggles or safety glasses
- Abrasive whetstone
- Mixing containers
- Palette knife or small metal spatula
- Small V-shaped carving tool
- Rubber gloves
- Sponge
- Cheesecloth or lint-free rags

Zodiac Bowls

Design: Jeni Stewart-Smith

Finished Size: 8" (20.5 cm) diameter

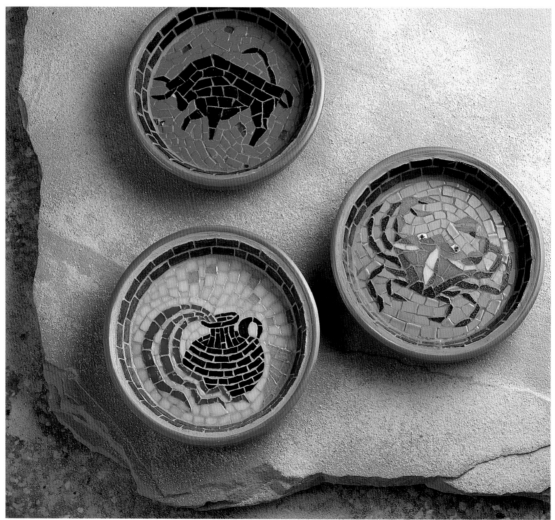

Photo: Evan Bracken

Even if you never consult your daily horoscope before making a major decision and you thought that star signs went the way of bell-bottoms, you're certain to find these strong, graphic designs appealing. Each symbol has just the right amount of detail to make it interesting yet still manageable within the format of a small terra-cotta dish. Executed using the direct method, the finished bowls are perfect for serving snacks, holding jewelry and hair ornaments, or displaying in a grouping.

INSTRUCTIONS

1 Cut a circle of carbon paper just large enough to fit the interior base of the terra-cotta dish. Then enlarge one of the figures shown or sketch a design and transfer it to the dish.

2 Using the tile nippers, cut a quantity of tesserae to fit the motif. In the Taurus design, relatively large, chunky pieces give the impression of strength; in the Aquarius dish, the flow of tiles on the pot emphasizes the roundness of the shape; the tesserae in the Cancer mosaic are deliberately made random to suggest the fragility of the crab.

3 Working in small areas at a time, apply a thin layer of tile adhesive to the dish with a palette knife. Butter the back faces of the tesserae and adjust their positions with a dental probe or similar tool.

4 Once you've completed the central motif, begin filling in the background. In each of these examples, the flow of tesserae in the background complements the shape of the subject and the roundness of the dish.

5 Work the sides of the dish in a contrasting or complementary color, using slightly larger rectangular tesserae. Place the final row of tesserae slightly below the lip of the dish and make sure that the beveled (cut) edge of each piece in this row faces upward.

Tools & Materials

- Vitreous glass tiles: black, light and dark green, deep turquoise, yellow, beige, blue, brown

- Ceramic tiles: red, turquoise, dark blue

- A few smalti

- 8" (20.5 cm) Terra-cotta dish

- Tile adhesive

- Dry grout

- Matte or satin polyurethane (optional)

- Tile nippers

- Goggles or safety glasses

- Carbon paper

- Palette knife or small metal spatula

- Dental probe or tweezers

- Rubber gloves

- Grout spreader

- Sponge

- Lint-free rags

- Paintbrush (optional)

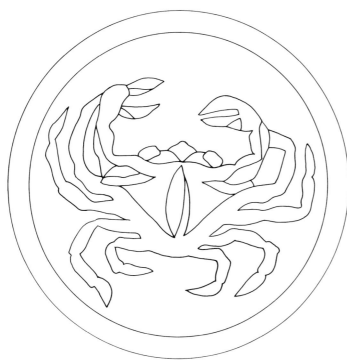

Artist's Tip

Store your tesserae in clear containers and try to keep all the shades of one color grouped together. In the heat of the moment, you'll find it much more satisfying to put your hands immediately on just the right color. If you accidentally place a blue piece where you wanted a green one, a pair of needle-nose pliers makes an excellent retrieval tool.

6 Allow the mosaic to dry for at least 24 hours.

7 Mix a small amount of grout as instructed by the manufacturer; then spread the grout over the surface of the mosaic and press it into the crevices. Wipe away any excess with a barely damp sponge or clean rag. To ensure that the lip is neat and even, you may need to wait about an hour and apply some additional grout. Remove any remaining haze with a lint-free rag, turning the rag frequently.

8 After several days, the entire dish can be brushed with a thin coating of matte or satin polyurethane if desired. This will seal the terra-cotta, which is quite porous if left untreated.

Contributing Artists

Carlos Alves
Miami Beach, Florida

Twyla Arthur
El Cerrito, California

Tom Ashcraft
University Park, Maryland

Karen Barnett
Argyle, Texas

Vanessa Benson
London, England

Chris Carbonell
New York, New York

Martin Cheek
Kent, England

Peter Columbo
South Hackensack, New Jersey

Alison Cooper
Pacific Palisades, California

Joanna Dewfall
Wiltshire, England

Joseph DiStefano
Emeryville, California

Ellen Driscoll
Cambridge, Massachusetts

Gary Drostle and Rob Turner
Wallscapes
London, England

George F. Fishman
Miami Shores, Florida

Ron Gasowski
Tempe, Arizona

Susan Goldblatt
London, England

Elaine M. Goodwin
Exeter, England

Nancy Gotthart
San Francisco, California

Susan Grossman
Chapel Hill, North Carolina

Debby Hagar
Knoxville, Tennessee

Dee Hardwicke
Gwent, England

Richard Hines
Berrien Springs, Michigan

Maggy Howarth
Lancaster, England

Michael Hurwitz
Philadelphia, Pennsylvania

Magnus Irvin
London, England

Roberta Kasserman and Gary
Bloom
Peacock Pottery Farm
Alamosa, Colorado

Shelby Kennedy
San Francisco, California

Gloria Koscow and Mimi Strang
Decoratta
Silverdale, Pennsylvania

Marcia and John Koverman
Cincinnati, Ohio

Jacob Lawrence
Seattle, Washington

Beverly Magennis
Albuquerque, New Mexico

Cheri Lai Mah
Berkeley, California

Toby Mason
Reflective Glass Mosaics
Vienna, Virginia

Will Mead
Peace Valley Tile
New Britain, Pennsylvania

Jane Muir
Bucks, England

Gifford Myers
Altadena, California

Laurel Neff
San Francisco, California

Ruth O'Day
Fireworks
Oakland, California

Jose Ortega
New York, New York

Jim Piercey
J. Piercey Studios
Orlando, Florida

Cathy Raingarden
Castro Valley, California

Elizabeth Raybee
Potter Valley, California

Kathryn Schnabel
Chicago, Illinois

Nina Smoot-Cain and Kiela
Songhay Smith
Chicago, Illinois

Jeni Stewart-Smith
Cornwall, England

Robert Stout
Twin Dolphin Mosaics
Albany, New York

Terry Taylor
Asheville, North Carolina

Zoe and Steve Terlizzese
Creative Union Gallery
West Palm Beach, Florida

Karen Thompson
San Francisco, California

Sven Warner
Mountaintop Mosaics
Castleton, Vermont

Susan Wick
Denver, Colorado

Lily Yeh and James Maxton
Philadelphia, Pennsylvania

Isaiah Zagar
Philadelphia, Pennsylvania

Acknowledgments

Heartfelt thanks are extended to all of the contributing artists; their boundless creativity and artistry have made this book a joy from start to finish. Special thanks go to George F. Fishman and Terry Taylor, who generously shared their work, their time, and their technical expertise. And thanks to George Ehling, whose unbounded enthusiasm for making mosaics is an inspiration to all who know him. Many thanks also to the following people for their invaluable assistance.

PAUL BENTLEY at *Mosaic Matters*, 68 Beresford Road, New Malden, Surrey, KT3 3RQ, England

CHRIS BLANCHETT at Tiles & Architectural Ceramics Books, 3 Browns Rise, Buckland Common, Tring, Hertsfordshire, HP23 6NJ, England

NOEMI GILBERT at Renato Bisazza, 8032 N.W. 66th Street, Miami, Florida 33166

JOSÉ LUIS PORCAR at Instituto de Promoción Cerámica, Diputación Provincial, Plaza de las Aulas, 7, 12001 Castellón, Spain

VERNE SMART at Dal-Tile International, 7834 Hawn Freeway, Dallas, Texas 75217

JOE TAYLOR at the Tile Heritage Foundation, P.O. Box 1850, Healdsburg, California 95448

SVEN WARNER at Mountaintop Mosaics, P.O. Box 653, Castleton, Vermont 05735

GRAHAM WHITE at Hastings/Il Bagno, 230 Park Avenue South, New York, New York 10003

R.H. YOUNG at Edgar Udny & Company, The Mosaic Centre, 314 Balham High Road, London, SW17 7AA, England

Glossary

Adamento – The general flow of a mosaic, which is determined by the direction of the tesserae and the grout lines

Direct method – The process of adhering tesserae face up directly onto a base to create a mosaic. This is a more spontaneous approach than the indirect method, and it results in a mosaic with slight variations in the surface texture.

Indirect method – A technique for assembling mosaics on temporary surfaces, such as kraft paper, clear adhesive film, or plastic mesh. The tesserae are stuck face down using a water-soluble adhesive (or the temporary adhesive on the film) and can be re-arranged as desired to create a design. The completed mosaic is then adhered to its permanent base and the temporary surface removed from its face.

Opus tessellatum – A Latin term meaning "set with small cubes." It refers to an arrangement of tesserae in a rectilinear pattern, an approach that is most often applied to background areas.

Opus vermiculatum - A Latin term meaning "wormlike work," this is a method for arranging tesserae in curving lines to emphasize the form of the design. Both subject and background areas can be done in *opus vermiculatum*.

Pique assiette – The term is French for "stolen plate," and it refers to the process of making mosaics using broken pieces of crockery, tiles, and various found objects. The designs that are created using this method may be abstract or representational, and they often contain elements of humor.

Tessera, tesserae – Latin terms for the basic units that together make up a mosaic. Although the word tessera literally means "cube," it can be applied to any type of material, from square glass tiles to irregular pieces of broken pottery.

Martin Cheek, *Punch Flip #5*, glass, smalti, and raku-fired ceramics, 19" x 19¾" (48 x 50 cm), 1993

Index

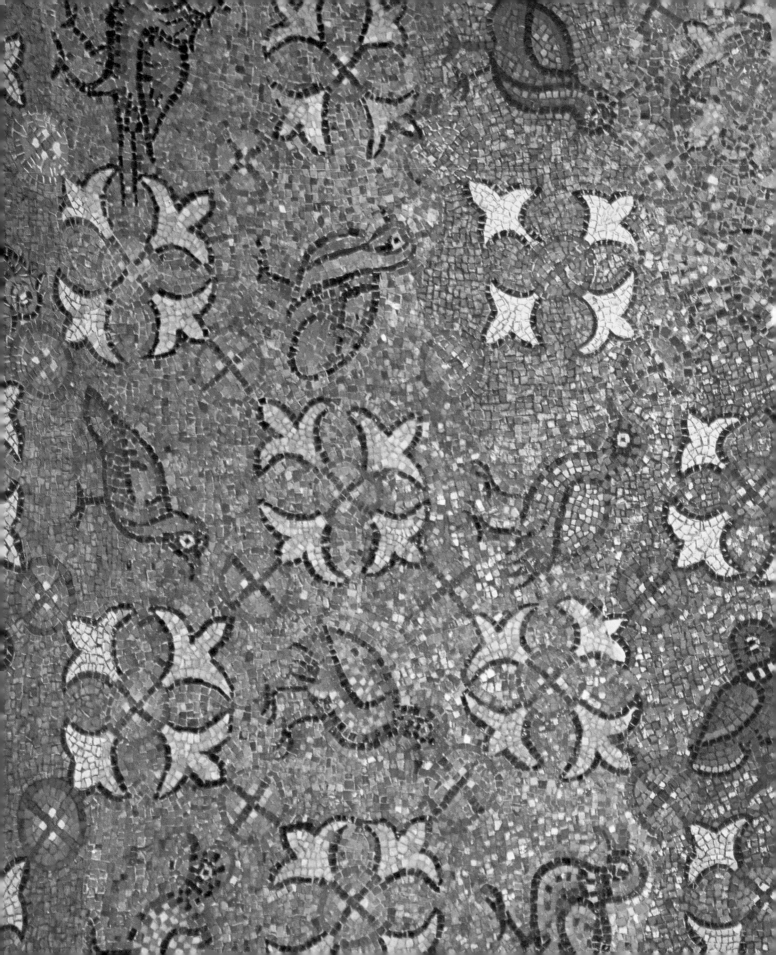